T0277468

FROME
MURDERS AND
MISDEMEANOURS

MICK DAVIS & DAVID LASSMAN

AMBERLEY

First published 2023

Amberley Publishing
The Hill, Stroud
Gloucestershire, GL5 4EP

www.amberley-books.com

British Library Cataloguing in Publication Data.
A catalogue record for this book is available from the British Library.

ISBN 978 1 3981 1140 0 (paperback)
ISBN 978 1 3981 1141 7 (ebook)

Orgination by Amberley Publishing
Printed in Great Britain.

CONTENTS

INTRODUCTION

'History is indeed little more than the register of the crimes, follies, and misfortunes of mankind.'

Edward Gibbon

The Somerset market town of Frome might today enjoy a reputation as the epitome of cool, but the place hasn't always been so chic, and behind its modern-day prosperity lies a dark side full of murder, witchcraft and madness. In fact, it has been hard to know what to leave out of this volume as there is enough material to fill many.

The very existence of Frome could be said to have been inspired by criminality; it is thought that Aldhelm, Abbot of Malmesbury, built his Saxon church in the

Frome in the 1860s. (Courtesy of Frome Museum)

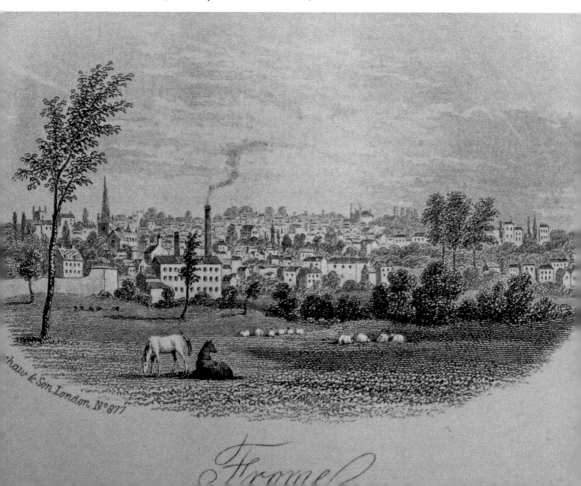

area to 'civilise' the outlaws and bandits who roamed the interior of Selwood Forest, the huge tract of woodland surrounding the land that became the town.

This volume chronicles nine dark but fascinating stories. It includes the Frome vicar who wrote a significant book on witchcraft, influencing everyone from Aleister Crowley to the perpetrators of the Salem witch trials; the evil Branch family who brutally murdered their servant; provides a fascinating glimpse into life as a parish constable; the murder of a genial farmer and his servant; the shooting of an aristocrat; the stabbing of a farm boy by his uncle; a local petty criminal who narrowly escaped transportation; a farmer who went mad and slaughtered his farmworkers; and a tragic murder/suicide in the heart of town.

The fortunes of Frome have always fluctuated wildly, often rising phoenix-like from the ashes of whatever industry had declined, finding new and lucrative opportunities to pursue. Meanwhile, the regular troughs of economic hardships in these transitions between poverty and prosperity have been acknowledged as a huge motiving factor in the cause of crime – desperate times call for desperate measures.

Every attempt has been made to seek permission for copyrighted material used in this book. However, if we have inadvertently used material without permission or acknowledgement, we apologise and will make the necessary correction at the first opportunity.

Mick Davis and David Lassman

Frome Market Place in the 1860s. (Courtesy of Frome Museum)

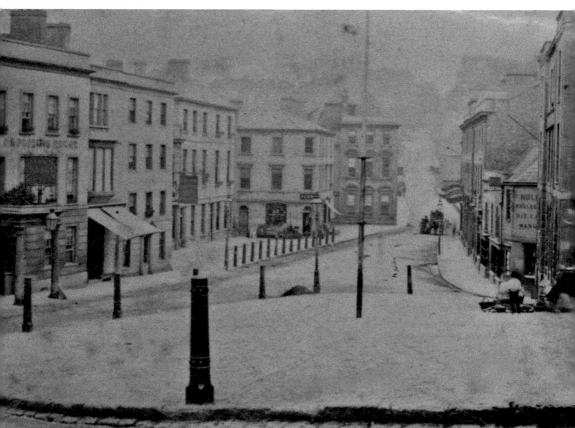

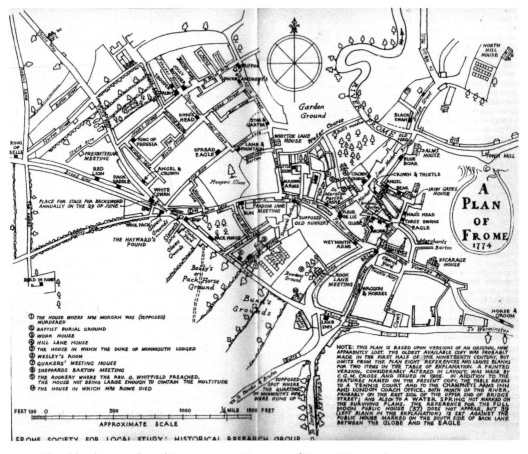

The oldest known plan of Frome, 1774. (Courtesy of Frome Museum)

1. THE BECKINGTON WITCHES

In the seventeenth century, the thriving village of Beckington, just 3 miles from Frome, was a centre of the local woollen industry, and had been since medieval times. Towards the end of that century it seems to have suffered a peculiar form of possession and an infestation of witches. In 1689, an anonymous, two-page pamphlet was published in London:

Great News from the West of England
Being a true account of two young persons lately bewitched in the town of Beckenton Somersetshire: Showing the sad condition they are in by vomiting or throwing out of their bodies the abundance of pins, needles, pewter, brass lead iron and tin, to the admiration of all beholders: And of the old Witch being carried several times to a great river into which her legs being tied, she was thrice thrown in; but each time she swam like a cork.

Beckington in around 1906.

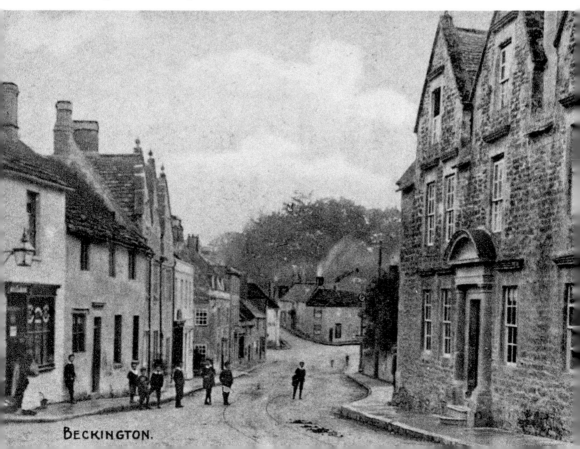

BECKINGTON.

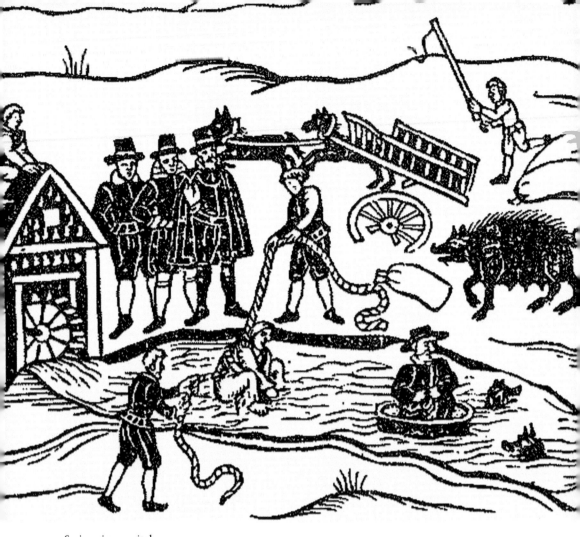

Swimming a witch.

The story runs that a girl of eighteen named Mary Hill who lived in the village with her brother and three younger sisters asked to borrow a ring from an old woman, and began threatening her for it when the request was refused. Some accounts name the old woman as Elizabeth Carrier, aged around eighty, who lived in the local almshouse. Despite repeated refusals the young girl persisted in her demands, and a while later Mary met the old woman in the street. Carrier took the girl by the hand and asked her to escort her to Frome to look for work, but Mary refused. The two met again four days later and the old woman begged an apple from her; again, Mary refused. The following Sunday, Mary began to have a pricking feeling in her stomach, and on Monday something arose in her throat and she fell into a series of violent fits. Four or five people were needed to restrain her. While in the throes of a fit, Mary complained that she 'saw this old Woman against the Wall, grinning at her, and being struck at, would step aside to avoid the blows'.

The following Wednesday, she began to vomit crooked pins. This lasted a fortnight, then she threw up nails and more pins. After an eight-day respite, she began throwing up 'Nails again, and Handles of Spoons, both of Pewter and Brass; several pieces of Iron, Lead, and Tin, with several clusters of Crooked Pins; some tied with Yarn, and some with Thread, with abundance of Blood between'. The townsfolk, concerned about Mary's condition, kept a close watch on her. On one occasion, although Mary alleged she did not know that Carrier was approaching, she fell into a strong fit; the old woman was apprehended for witchcraft on this evidence. Despite this, the fits continued, as did her vomiting nails and spoon handles. Her vomiting is said to have been triggered by drinking small beer – a very common low-alcoholic beverage that was thought of as being cleaner than water.

This was not the only time that the old crone had been subject to allegations of witchcraft. On another occasion, local eighteen-year-old William Spicer took to calling her a witch, which so upset her that she reported him to the local justice of the peace, who issued a warrant compelling the lad to apologise and leave her alone. Despite agreeing to do so Spicer 'fell into the strangest fits that ever a mortal beheld with eyes'. This state of affairs continued for two weeks, and he claimed that while having these fits he saw visions remarkably similar to those of Mary Hill. 'He did see this old woman against the wall in the same room of the house where he was and that sometimes she did knock her fist at him; sometimes grin her teeth and sometimes laugh at him in his fits.' He also began to throw up 'great quantities of crooked pins to the number of thirty and upwards'.

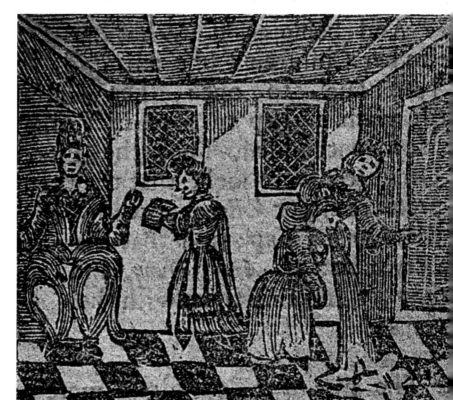

Mary Hill throws up some cutlery.

Other accounts give even more robust accounts of Mary Hill's internal scrapyard:

> She began to throw up nails and pins, handles of spoons, both of pewter and brass, several pieces of iron, lead and tin with several clusters of crooked pins, sixteen or seventeen in a cluster, seven pieces of pewter, four pieces of brass, being handles of spoons, six pieces of lead, some whereof were handles of spoons and some the lead of a window, besides one solid piece of lead which weighed a full two ounces; six long pieces of latten, with wire belonging to them; five pieces of iron one whereof was round but hollow and very big; and two and twenty nails some whereof were board-nails above three inches and a quarter long.

One wonders if the objects she brought up were ever compared to those produced by Mr Spicer or if the two were known to spend much time together, or if anyone asked the village blacksmith if he recognised his own handiwork among the scrap. Word of the marvels spread and Mary received a visitor from Castle Cary:

> I well remember a gentleman, on a Saturday, came to my house (Incognito) to know of me the truth of the country report about this maid, having seen some of the nails &c she had vomited up. I told him it was very true, and, if he would stay in town till the morning, he might see it himself, for his own satisfaction. Which he did, and, early in the morning, was called to see her. But, because beer was not given her when she wanted it, she lay in a very deplorable condition, till past two in the afternoon, when, with much difficulty, she brought up a piece of brass, which the said gentleman took away with him. Though, before the said piece of brass came up, he told me he was satisfied of the truth of the thing, because it was impossible for any mortal to counterfeit her miserable condition. She, sometimes, lying in a dead fit, with her tongue swelled out of her head, and then reviving, she would fall to vomiting, but nothing came up till about two a clock in the afternoon.
>
> Nay, so curious was he to anticipate any cheat, that he searcht her mouth himself, gave her the beer, held her up in his hand, and likewise the bason into which she vomited, and continued with her all this time, without eating and drinking, which was about eight hours, that he might be an eye-witness of the truth of it. Nay, further, he found the maid living only with a brother, and three poor sisters, all young persons, and very honest, and the maid kept at the charge of the Parish, were sufficient testimonies that they were incapable of making a cheat of it. The gentleman I now mentioned, was (as I afterwards learnt) esquire Player of Castle-Cary.

In 1691, Richard Baxter published a book entitled *The Certainty of the World of Spirits Fully Evinced*. Among many weird and wonderful accounts of mysterious

goings on, he reports in greater detail on the events surrounding Mary Hill and is obviously taken in by her antics:

Mr John Humphreys brought Mr May Hill to me, with a bag of irons, nails and brass, vomited by a girl. I keep some of them to show: nails about three or four inches long, double crooked at the end, and pieces of old brass doubled, about an inch broad and two or three inches long with crooked edges. I desired him to give me the case in writing which he hath done as followeth. Any one that is incredulous may now at Beckington receive satisfaction from him, and from the maid herself.

In the town of Beckington, by Froome in Somersetshire, liveth Mary Hill a maid of about eighteen years of age, who, having lived very much in the neglect of her duty to God, was some time before Michaelmas last past, was twelve-month, taken very ill, and, being seized with violent fits, began to vomit up about two hundred crooked pins. This so stupendous an accident, drew a numerous concourse of people to see her, to whom, when in her fits, she did constantly affirm, that she saw against the wall of the room wherein she lay, an old woman, named Elizabeth Carrier, who, there upon, being apprehended by a warrant from a Justice of Peace, and convicted by the oaths of two persons, was committed to the county gaol.

About a fortnight after, she began to vomit up nails, pieces of nails, pieces of brass, handles of spoons, and so continued to do for the space of six months and upwards. And, in her fits, she said there did appear to her an old woman, named Margery Coombes, and one Ann Moore, who, also, by a warrant from two justices of the peace, were apprehended and brought to the sessions, held at Brewton, for the county, and, by the bench, committed to the county gaol. The former of these dyed as soon as she came into prison. The other two were tried at Taunton Assizes, by my Lord Chief Justice Holt and for want of evidence, were acquitted by the jury. Whereupon Mr Francis Jesse and Mr Christopher Brewer declared, that they had seen the said Mary Hill to vomit up, at several times, crooked pins, nails, and pieces of brass, which they, also, produced in open Court, and to the end, they might be ascertained it was no imposture, they declared they searched her mouth with their fingers before she did vomit.

Upon which, the Court thought fit to call for me, who am the minister of the parish, to testify the knowledge of the matter, which I did to this effect, that I had seen her, at several times, after having given her a little small beer, vomit up crooked pins, nails, and pieces of brass. That, to prevent the supposition of a cheat, I had caused her to be brought to a window, and, having lookt into her mouth, I searcht it with my finger, as I did the beer before she drank it. This I did, that I might not be wanting in circumstantial answers to what my Lord and Court might propose.

After the Assizes was ended and she was turned home, she grew worse than ever, by vomiting of nails, pieces of glass, &c. And, falling, one day, into a violent fit, she was swelled to an extraordinary bigness. Some beer being given her, she throws up several pieces of bread and butter, besmeared with a poysonous matter, which I judged to be white mercury. This so affrighted the neighbours, that they would come no more near her. So that one day, she being taken desperate ill, I was sent for to pray with her; and compassionating the deplorableness of her condition, I at last resolved to take her into my own house where in some short time the vomiting ceased, though for some space her distorting fits followed her. But blessed be God, is now and has been a considerable time past, in very good health and fit for service.

May Hill, Minister of Beckington

4 April 1691

The villagers were becoming more concerned about the bizarre situation, and eventually, the local JP ordered a search for the Devil's mark to be carried out. She was found to have several purple marks on her skin, which when pricked with a pin caused no pain – a definite maybe when it came to witch hunting. The ultimate test came next: she was thrown into the local river and bobbed about like a cork. This was proof enough that she was in league with the Devil, as if she had sunk she would have been innocent. To ensure fairness, one report states that a 'lusty young woman' was also thrown in and sank like a stone. The poor

Beckington Church.

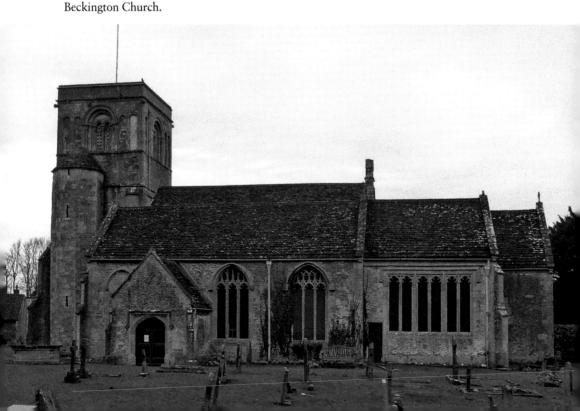

girl would have drowned had she not been rescued quickly. This was deemed proof enough and the old woman was packed off to Ilchester Gaol to await her trial for witchcraft at the next assizes, but as described above she died almost as soon as she arrived, which is no surprise considering her age and what had just happened to her.

Two other women, Margery Combes and Anne More, were also arrested in connection with Mary Hill's fits. Her vomiting was attested to in court by witnesses Susanna Belton, Ann Holland, Francis Jesse and Christopher Brewer. Belton and Holland brought numerous objects Mary was said to have vomited to court as evidence, while Jesse and Brewer gave deposition that they had searched Mary's mouth with their fingers before she vomited and were convinced she could not have faked it. John Humphreys observed that Mary vomited nails in the morning, slept with her mouth open, groaned in her sleep, was impossible to wake, and was much weakened by her vomiting. Even after the assizes, Humphreys reported that she vomited nails and glass, and days later she swelled up and vomited bread and butter contaminated with white mercury.

The outcome of the case was an acquittal due to lack of evidence, which shows that not everybody was taken in by the charade. With the main witch dead and Mary with a job at the vicarage, things probably settled down and the village got back to normal.

2. JOSEPH GLANVILL AND THE WITCHES
OF BREWHAM

The Beckington Witches were not the area's only involvement with witchcraft. The vicar of Frome, a couple of miles down the road, was for a short time Joseph Glanvill (1636–80) – a philosopher and clergyman whose name deserves to be better known. Glanvill studied religion, logic and philosophy at Oxford before becoming chaplain to Sir James Thynne at Longleat, who bestowed the vicarage of 'Froome Selwood' upon him in May 1662. He didn't stay long though as he was appointed to be rector of Abbey Church in Bath by 1666 and is buried in Bath Abbey.

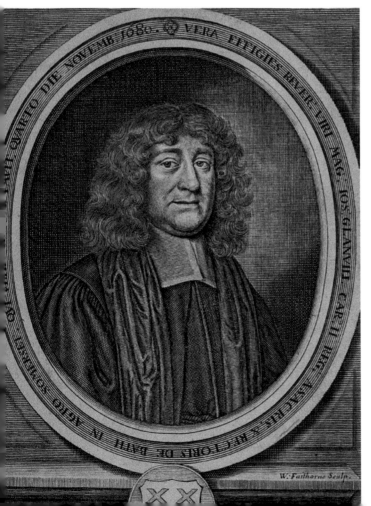

Joseph Glanvill, 1636–80.

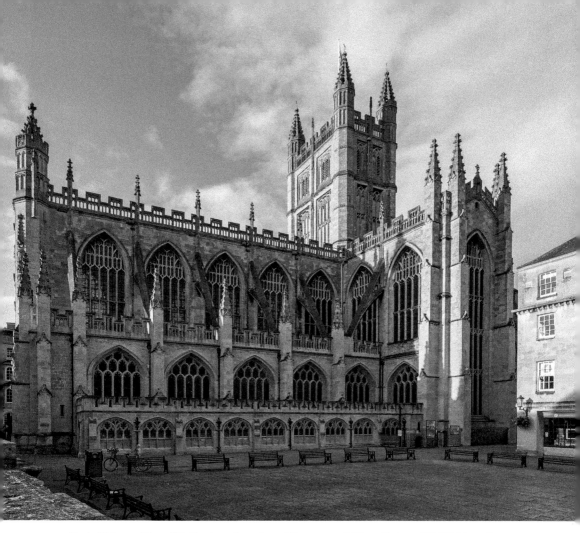

Bath Abbey – Glanvill's final resting place. (Courtesy of Diego Delso, CC-BY-SA 3.0)

His education in logic at Oxford seems to have stood him in good stead, enabling him to be a Presbyterian under the Commonwealth and an Anglican and royalist once the monarchy was restored. Glanvill was an exponent of freedom of religious thought, toleration and scientific method, a Nonconformist in all but name, who supported plain language and thought that the existence of God and the supernatural should be capable of empirical proof.

He wrote a number of books but his relevance here is the production of *Sadducismus Triumphatus or Full and Plain Evidence Concerning Witches and Apparitions*, a book on witchcraft that went through a number of editions before reaching its final form in 1681 – the year after he died. Within this book, he examines the evidence for and against the existence of witches before giving a number of case histories from Ireland to Sweden. Among them is this little tale from Brewham on the Wiltshire borders, around 7 miles from Frome. The examiner, Robert Hunt, was a magistrate from Wincanton.

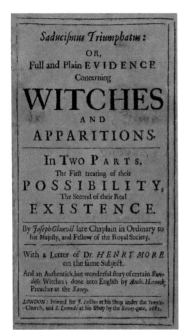

Left: Glanvill's book of 1681.

Below: St John's Church, Frome.

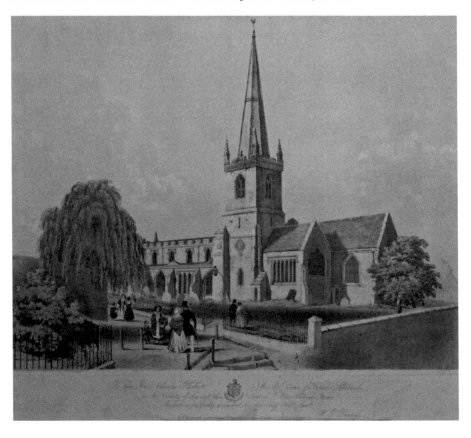

The examination and confession that follows is from Catherine Green, aged around thirty-three years, wife of Rob Green of Brewham in the county of Somerset, and was taken before Rob Hunt Esq. on 2 March 1664.

This Examinant saith that about a year and a half since, (being in great poverty) one Catherine Green of Brewham that if she would she might be in a better condition and then persuaded her to make a covenant with the devil. Being afterwards together in Mr Hussey's ground in Brewham Forest about noon Catherine called for the devil who appeared in the shape of a man in blackish clothes and said somewhat to Catherine that Christian could not hear. After which the devil, (as she conceived him) told the Examinant that she would want neither Clothes, Victuals, nor Money, if she would give her body and soul to him, keep his secrets and suffer him to suck her once in twenty four hours, which at last upon his and Catherine Green's person she yielded to; then the man in black pricked the forth finger of her right hand between the middle and upper joints, where the sign yet remains and took two drops of blood on his finger, giving her fourpence halfpenny, with which she after brought bread in Brewham. Then he spake again in private with Catherine and vanished leaving a smell of brimstone behind.

Since that time the Devil, (she saith) hath and doth usually suck her left breast about five of the clock in the morning in the likeness of a hedge-hog bending, and did so on Wednesday morning last. She saith it is painful to her and that she is usually in a trance when she is sucked.

She saith also that Catherine Green and Margaret Agar of Brewham have told her that they are in covenant with the devil and confesseth that she hath been at several meetings in the night at Brewham Common and in a ground of Mr. Hussey's, that she hath met there Catherine Green and Margaret Agar and three or four times with Mary Warberton of Brewham, That in all those meetings the Devil hath been present in the shape of a Man in Black Clothes. At their first coming he bids them welcome, but always speaks very low.

That at a meeting about three weeks or a month since at or near the former place Margaret Ager brought thither an image in wax for Elizabeth the wife of Andrew Cornish of Brewham, and the Devil in the shape of a man in black clothes did baptise it and after did stick a thorn into its head; that Agar stuck one into its stomach and Catherine Green one into his side. She further saith that before this time, Agar said to this Examinant that she would hurt Elizabeth Cornish who since the baptising of the picture hath been taken, and continues very ill.

She saith that three or four days before, Jos. Talbot of Brewham dyed; Margaret Agar told her that she would rid him out of the World because being Overseer of the Poor he made her children go to service and refused to give them such good Clothes as she desired. And since the death of Talbot, she confessed to the Examinant that she had bewitchit him to Death. He died about a year since, was taken ill on Friday and dyed about Wednesday after.

That her mother-in-law Catherine Green about five or six years ago was taken in a strange manner. One day one eye and cheek did swell, another day, another, and so she continued in great pain, till she died. Upon her death she several times said in the hearing of the Examinant, that her sister-in-law Catherine Green had bewitched her and the Examinant believes that she bewitched her to Death.

That a little before Michaelmas last, the said Catherine cursed the horses of Rob Walter of Brewham, saying a Murrain on them to death. Upon which the horses being three all dyed.

Taken before me Rob Hunt.

Containing further Testimonies of the villainous feats of that rampant hagg Margaret Agar of Brewham in the County of Somerset.

1. Elizabeth Talbot of Brewham Examined 7 March 1664 before Rob. Hunt, Esq saith, That about three weeks before her Father Jos. Talbot dyed, Margaret Agar fell out with him, because he being Overseer for the Poor, did require Agar's Daughter to go to Service, and said to him, that he was proud of his living, but swore by the blood of the Lord, that he should not long enjoy it. Within three weeks of which he was suddainly taken in his body as if he had been stabb'd with Daggers, and so continued four or five days in great pain and then dyed.
Rob. Hunt.

2. Jos. Smith of Brewham, Husbandman, Examined 15 March 1664. before Rob, Hunt, Esq saith, That some few days before Jos. Talbot dyed, he heard Margaret Agar rail very much at him, because he had caused her Daughter to go to Service, and said, that he should not keep his living but be drawn out upon four Men's shoulders. That she should tread upon his jaws, and see the grass grow over his head, which she swore by the blood of the Lord.
Taken upon Oath before Rob. Hunt.

3. Mary the Wife of William Smith of Brewham, Examined 8 March 1664. before Rob. Hunt, Esq saith, That about two years since Margaret Agar came to her, and called her Whore, adding, A Plague take you for an old Whore, I shall live to see thee rot on the Earth before I die, and thy Cows shall fall and die at my feet. A short time after which, she had three Cows that died very strangely, and two of them at the door of Margaret Agar. And ever since the Examinant hath consumed and pined away, her Body and her Bowels rotting, and she verily believes that her Cattle and her self were bewitcht by Agar.
Taken upon Oath before Rob. Hunt.

4. Catharine Green alias Cornish of Brewham, Widow, Examined 16 May 1665. before Rob. Hunt, Esq saith, That on Friday in the Evening, in the beginning of March last, Margaret Agar came to her, and was earnest she should go with her to a Ground called Husseys-knap, which she did, and being come thither they saw a little Man in black Clothes with a little band. As soon as they came to him Margaret Agar took out of her lap a little Picture in blackish Wax, which she delivered to the Man in black, who stuck a Thorn into the Crown of

the Picture, and then delivered it back to Agar. Upon which she stuck a Thorn towards the heart of the Picture, Cursing and saying, a Plague on you; which she told the Examinant was done to hurt Eliz. Cornish, who as she hath been told hath been very ill ever since that time.

That a little above a year since Jos. Talbot late of Brewham, being Overseer for the Poor, did cause two of Agar's Children to go to Service. Upon which she was very angry and said in the Examinants hearing a few days before he fell sick and died, that she had trod upon the jaws of three of her Enemies, and that she should shortly see Talbot rot and tread on his jaws. And when this Examinant desired her not to hurt Talbot, she swore by the blood of the Lord, she would confound him if she could. The day before he dyed, she said to the Examinant, Gods wounds I'll go and see him, for I shall never see him more; and the next day Talbot dyed.

That she heard Margaret Agar curse Mary Smith, and say, she should live to see her and her Cattle fall and rot before her face.

Taken upon Oath before Rob. Hunt.

5. Mary Green of Brewham, single Woman, Examined 3 June 1665. before Rob. Hunt, Esq saith, That about a Month before Jos. Talbot late of Brewham dyed, Margaret Agar fell out with him about the putting out of her Child to Service. After that she saw a Picture in Clay or Wax in the hands of Agar, which she said was for Talbot, the Picture she saw her deliver in Redmore, to the Fiend in the shape of a Man in black about an hour in the Night, who stuck a Thorn in or near the Heart of it, Agar stuck another in the Breast, and Catharine Green, Alice Green, Mary Warberton, Henry Walter and Christian Green, all of Brewham, were then and there present, and did all stick Thorns into the Picture. At that time Catharine Green spake to Agar not to hurt Talbot, because she received somewhat from him often times, but Agar replied, by the Lords blood she would confound him, or words to that purpose.

That a little before Talbot was taken sick; Agar being in the house where the Examinant lived, swore that she should e're long tread upon his jaws. And that if Talbot made her Daughter go to Service for a year, yet if she came home in a quarter it would be time enough to see him carried out upon four Mens shoulders and to tread upon his jaws.

That on the day Talbot dyed, she heard Agar swear that she had now plagued Talbot; and that being in company with her some time before, and seeing a dead Horse of Talbot's drawn along by another of his Horses, she swore that that Horse should be also drawn out to morrow, and the next day she saw the well Horse also drawn out dead.

That above a Month before Margaret Agar was sent to Gaol, she saw her, Henry Walter, Catharine Green, Jone Syms, Christian Green, Mary Warberton and others, meet at a place called Husseys-knap in the Forrest in the Night time, where met them the Fiend in the shape of a little Man in black Clothes with a

littleband, to him all made obeysances, and at that time a Picture in Wax or Clay was delivered by Agar to the Man in black, who stuck a Thorn into the Crown of it, Margaret Agar one towards the Breast, Catharine Green in the side; after which Agar threw down the Picture and said, there is Cornishes Picture with a Murrain to it, or Plague on it. And that at both the meetings there was a noisom smell of Brimstone.

That about two years since in the Night there met in the same place Agar, Henry Walter, Catharine Green, Jone Syms, Alice Green and Mary Warberton. Then also Margaret Agar delivered to the little Man in black a Picture in Wax, into which he and Agar stuck Thorns, and Henry Walter thrust his Thumb into the side of it. Then they threw it down and said, there is Dick Greens Picture with a Pox in't. A short time after which Rich. Green was taken ill and dyed.

Further he saith, That on Thursday Night before Whitsunday last, about the same place met Catharine Green, Alice Green, Jone Syms, Mary Warberton, Dinah and Dorothy Warberton and Henry Walter, and being met they called out Robin. Upon which instantly appeared a little Man in black Clothes to whom all made obeysance, and the little Man put his hand to his Hat, saying, How do ye? speaking low but big. Then all made low obeysances to him again. That she hath seen Margaret Clark twice at the meetings, but since Margaret Agar was sent to Prison she never saw her there.

Taken before me Rob. Hunt.

It is a common fallacy that witches were burnt at the stake if convicted. This did happen in some cases, but the usual sentence was death by hanging, and this is what befell Julian Cox upon her conviction. The fate of the others is not recorded.

A traditional witch with her familiar.

3. THE MURDER OF JANE BUTTERSWORTH

Elizabeth Bathory, Mary Ann Cotton, Myra Hindley, Rosemary West; history is replete with sadistic female killers, often with male accompaniment, but a mother and daughter must be quite rare. At the Somerset Assizes in Taunton Castle on 31 March 1740, Elizabeth Branch and her twenty-four-year-old daughter Mary, usually known as Betty, stood side by side before Mr Justice Chapple, who charged them with the sadistic murder of one of their serving girls several months before.

Elizabeth Branch (née Parry) came from a Bristol family, the daughter of a ship surgeon who became master of his own ship and made a great deal of money. So much in fact that after providing his daughter with a 'sober and religious education' he was able to give her almost £2,000 on the occasion of her marriage to Benjamin Branch. By some accounts, Branch was a farmer and others an attorney, though there is no reason why he shouldn't have been both.

Taunton Castle, scene of the Somerset Assizes. (Courtesy of Frome Museum)

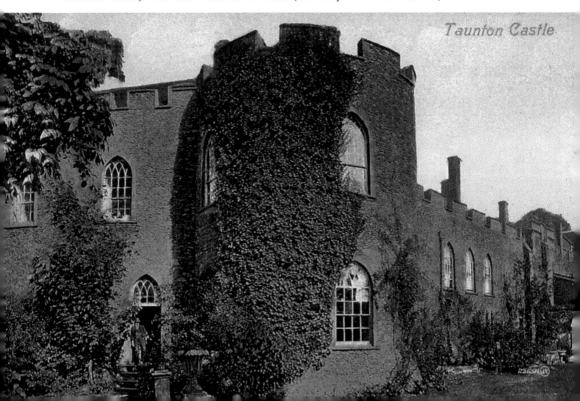

By comparison, the average farm labourer earned around £25 a year. It seems that their marriage wasn't a happy one and Benjamin's death was, as a contemporary pamphlet put it, 'not without imputations and strong circumstances of poison from her'. There were also rumours of her having murdered her own mother and hanged the corpse as a suicide to avoid investigations into her death. And then there was the discovery of human bones in the well on the farm shortly after the disappearance of one of her servant girls, who was never seen again…

By 1739, Elizabeth was sixty-six and lived with her daughter Mary and son Parry at Highchurch Farm, Hemington, near Frome. Today the farm in Chickwell Lane is home to children's character Tractor Ted and a chocolate workshop – a place of happy farmyard tours and children's summer holidays. In 1739, however, things could not have been more different.

With her husband out of the way, and his money to add to her own, Elizabeth was a woman of substantial means and more than able to do as she liked. Elizabeth had gained a reputation for treating her female staff and servants extremely badly and it seems that her daughter Mary was following in her footsteps. Rumours had been circulating for some time about their meanness and cruelty – so much so that they were unable to obtain staff locally. The unpleasant pair turned to John Lawrence, an acquaintance of theirs, for help and he found a thirteen-year-old orphan named Jane Buttersworth in Bristol.

Jane was tricked into believing she was being given an apprenticeship, which would mean she would have far fewer rights than a simple employee and that for a set number of years – normally five or seven – she would be fed, clothed, looked after and receive an education and training in whatever profession she wished to pursue, emerging with a qualification. The truth, though, was very different. As well as Jane, they also obtained the services of Ann James, a strong milkmaid from Wales. Like Jane, she had only been there for a few months. From the start it was Jane who was picked on. Her employers found fault with every little thing she did, and it seems she was often beaten and made to sleep outside the house.

Despite the strong evidence against them, the pair had not been without hope as they had brought a considerable sum of money with them to bribe jurors, but this ruse was discovered before the trial and the juryman changed.

Milkmaid Ann James was called first and told how she and Jane lived together at the farm in service to Mrs Branch and that Jane had always behaved herself in an orderly and civil manner, performing her duties to the best of her ability. Branch and her daughter Mary were very passionate people, she explained, and she had often seen them beat Jane for very little reason.

On Tuesday 12 February 1740, Jane was set to the village of Faulkland, around half a mile away, to buy some bran from Anthony Budd, but returned empty handed saying that they didn't have any. Early the next morning, Budd's son, William, who did the occasional bit of labouring for Mrs Branch, arrived at the farm to help Parry Branch cut up some timber and was asked why they had no bran to sell. They replied they had plenty, but no one had asked for any. Jane

The old stocks in the village of Faulkland.

insisted that she had been, which made Elizabeth very angry, and she ordered Ann to go the farm and find out the truth of the matter. Ann met Anthony Budd's wife, Margaret, who also insisted that Jane had not called. It must have been with a heavy heart that Ann brought the news back to the farm. Mary Branch flew into a rage and began beating Jane about the head with her fist and pinched and pulled her ears. Elizabeth joined in and they threw her face down on the floor and both began beating her with sticks. Ann tried to intervene, suggesting that it was better to send the girl back where she came from than to keep beating her so.

Jane begged to be spared and promised to reform, but Mary then kneeled on her neck while her mother whipped upon her skin until she bled. The daughter then took off one of the girl's shoes and beat her about the breech and hips with the heal, keeping her knee upon the ground as her mother continued whipping. Ann asked them to stop but they said that it was none of her business and continued to beat her about the head and shoulders. She tried to run but they followed, beating her with sticks into the kitchen until blood was pouring from the front of her head and down onto her shoulders. They told Ann to fetch a pail of water, which they threw over her to wash off the blood. The evil pair were by now exhausted but determined to continue their torment. They told her to scour a kettle, which she was unable to do as she was so weak. They tried to get her to dust out the hall and parlour, but she was so injured that she could hardly move, leaning her head on her shoulder and groaning very much.

They sent Ann to find out what she was doing, who found her slumped against a wall with her head upon her hand. She tried to sweep the parlour but used the broom to hold herself up, claiming she 'felt as giddy as a goose'. Ann reported back that she was in no state to sweep even though she was trying, to which they

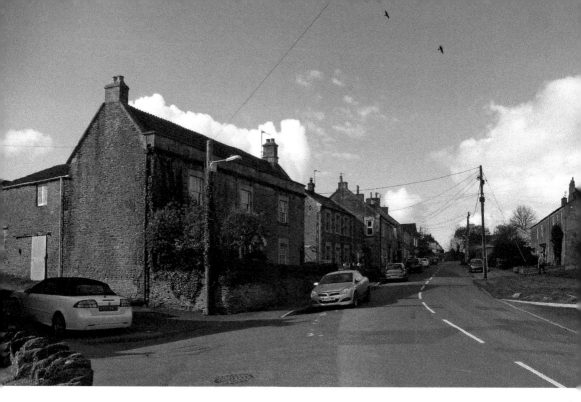

Above: The village of Faulkland.

Right: An artist's impression of Mrs Branch and her daughter. (From the Newgate Calendar)

Mrs. Branch and her Daughter cruelly beating Jane Buttersworth.

ELIZABETH AND MARY BRANCH,

replied that she was very cunning and began to beat her about the head again, saying that if she didn't dust the room they would through her down the stairs and break her neck.

The evil pair, still seemingly oblivious to how badly they had injured the girl, told Ann to send her to Faulkland to get some hops, but when she came to speak to her she was 'sunk down on her breech on the floor and answered 'I know the way', and seemed much altered in her voice and looks'. They next ordered her to wash the dishes, to which she replied that she was unable to move, so Ann half carried her into the brewhouse and set her down by the fire, by now believing that she was losing her senses. Still claiming that she was acting and lazy, Mary told Ann to fetch some salt, saying that 'if she did not make haste with the dishes she would salt her breech for her'. Jane said that she would, but she was unable to move. She was laid upon her side and 'she rubbed her breech bloody as before with the whipping with the salt' but by now she was too far gone to react. Ann tried to get her to eat some bread and cheese, but it was to no avail. She had her head in her hands and was groaning very much.

They removed her blood-soaked bonnet and replaced it with a new one, but that was soon as bloodied as the first. It seems they were at last beginning to worry about what they had done. Jane was no longer able to speak, and Ann told the pair she thought she was dying, which they denied, saying that they had 'just given her a dram', putting a hand into her mouth and saying that there was life left in her. Ann was ordered to take the girl up to bed, and by now it was six o'clock in the evening. She was sent out for wine and didn't get back until about 8 p.m. She went into the bedroom upon her return and found that Jane Buttersworth was dead. Elizabeth asked how she was so Ann told her, upon which she was called a 'Welsh bitch' and was accused of lying so that she would not have to share a bed with her nor have to attend to her in the night. Ann was sent to bed at about 11 p.m. and lay next to the corpse, keeping her clothes on and not touching it, remaining wide awake until 5 the next morning.

The Branch's had to accept the obvious and cover their tracks as best they could. It was now Thursday 14th and Ann was told to help William Budd measure up for a coffin but without drawing back the bed sheets and exposing the injuries to his gaze. Budd tried, but inadvertently saw a leg, which was black with bruises. He was then sent into Frome to purchase a coffin and shroud. The corpse lay there all day and night, and on the Friday Ann was told to wash it and try to hide the injuries, which she did as best she could, quickly wrapping it in a shroud. Another day went by and on the Sunday morning, with the help of John Lawrence, the covered body was put into the coffin. The blood-drenched clothes were hidden in the apple room and the Jane Buttersworth was buried the same day.

Francis Coombes, the sexton, was called next. He said that William Budd had come to him on the Friday and bid him to toll the bell, even though she had died on the Wednesday and it should have been rung then. Elizabeth asked Coombes how deeply the coffin was buried, to which he replied something in the order

of a yard, which was deeper than normal as he had even dug into the rock. She said that was not deep enough and asked if he had covered it well; he replied that he had. Elizabeth's questions roused suspicions and rumours began to spread through the village, and given the bad reputation of Branch pair they probably didn't need much encouragement.

Two locals, Robert Carver and John Marchant, decided to investigate. They obtained the key to the church by saying they would ring the bell for Ash Wednesday, then, with some others, dug up the coffin and carried it into the church. They opened it with great difficulty as it had been hammered down with huge nails. At this point, the men sent for the women of the village to examine the corpse, intending to rebury it and say nothing if all was found to be in order. When the women came in, the men withdrew to the other end of the church.

Mary Vigor and Betty Marchant deposed that they found the body greatly bruised and wounded and thought it came by a violent death. Carver and Marchant put the lid back on the coffin, locked up the corpse in the church and took the key to John Craddock, the church warden. The next morning, they went to the constable at Faulkland and mother and daughter were arrested, along with Ann James, and taken into custody at the Faulkland inn.

The church at Hemington. (Bath City Archives)

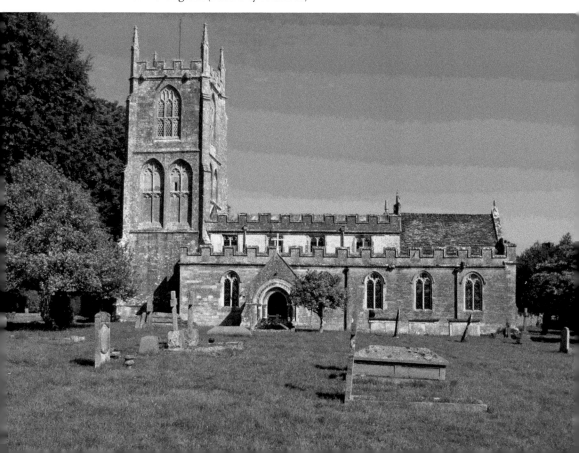

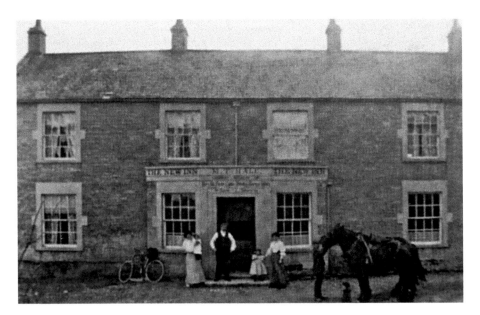

The inn at Faulkland.

The farm was searched and the bloody sticks used in the assault were discovered, but despite an extensive search the girl's clothes could not be found. Henry Butler, a former servant, was called and stated that he had seen the girl beaten many times and that they used to beat him. He said they had once beaten him so badly that 'he had beshat himself and that each of them had taken a handful of his excrement in their hand thrust it into his mouth and made him eat it'.

The coroner's inquest was held on 22 and 23 February 1740 by Dr Salmon, who examined the body and found many fractures to the skull; skin torn off on one hand, revealing the muscles and tendons; and the back, arms, thighs and legs were a mass of bruising, as were the breasts and stomach. He concluded that in general she appeared to have been so barbarously and inhumanly beaten that it was enough to kill the stoutest man or fell an ox. He had never seen a body treated so barbarously. Once the appalling chain of events was revealed a verdict of 'wilful murder' was reached.

The prosecution had more witnesses to call who could have expanded on the cruelties and injustices of the women towards Jane and others, but it was believed they had proved enough and the defence was called upon to put its case.

THE DEFENCE

The prisoners employed their own doctor, a surgeon and apothecary from Bradford, to support their claim that they did beat her but that if she had any wounds to the head these must have happened when she fell over carrying a pail of water. They claimed further that many of the wounds had been caused on the body after it had been exhumed by the villagers, who bore them a great deal of

malice. To his credit, the good doctor replied that he was bound to tell the truth in court and that if he thought that the injuries were caused before death he was bound to say so. Mrs Branch refused to let him see the body, paid him a guinea for his trouble and sent him on his way. The financial resources of the prisoners enabled them to engage the services of no less than eight for their defence counsel.

Mrs Branch claimed that the prosecution was malicious and that they had taken Buttersworth in when she was destitute of friends; they fed and clothed her. John Lawrence deposed that the girl had always been used civilly by her mistresses, but that there were some differences between her and Ann James, who he had seen strike her several times. He also said he had often heard Jane complain about being threatened and abused by her. It was Ann who had wrapped the corpse and put it in the coffin. Other people were brought forward to blame Ann in much the same vein, presumably paid to lie, but it was all rubbish and to no avail. The only option open to the prisoners was to blame Ann and, unsurprisingly, despite their bribes, it didn't work. The elder Branch did not change her countenance during the trial and did not react to the verdict, but had several times kicked Mary Vigor when she was giving evidence against her. The whole trial lasted just six hours and the jury were able to reach a verdict of guilty without leaving court.

Sentencing was put over to the next day while the prisoners complained that the trial had been illegal because the jury had been changed and if they had been tried in front of the original line-up they would have been acquitted – almost a certainty, given that many had been bribed. Elizabeth's attitude seemed to be that at the age of sixty-eight her life was close to its end. Her daughter fainted for about 45 minutes and, as someone tried to give her a dram to revive her, the ever-caring mother exclaimed, 'Zounds! What are you going to do; had not she better die thus than live to be hanged?'

Ilchester Jail.

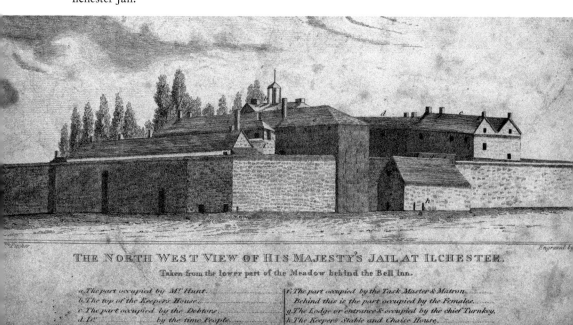

THE NORTH WEST VIEW OF HIS MAJESTY'S JAIL AT ILCHESTER.
Taken from the lower part of the Meadow behind the Bell Inn.

a. The part occupied by Mr Hunt.
b. The top of the Keepers House.
c. The part occupied by the Debtors.
d. Do by the fine People.
e. Do by the Felons.
f. The part occupied by the Task Master & Matron.
 Behind this is the part occupied by the Females.
g. The Lodge or entrance & occupied by the chief Turnkey.
h. The Keepers Stable and Chaise House.
i. The Road to & from London.

During her time in Ilchester jail, Mrs Branch behaved in a sullen manner and seemed to be more interested in her personal comfort than any thoughts of the afterlife. She took a keen interest in the mechanics of execution, however, asking why the hangman always put the knot of the halter to the left ear. Her daughter seemed to get on well with the jailer, sometimes walking out with him to a house he had about a mile from Ilchester. The date of the execution was set for 3 May 1740 and, having given up all hope of mercy, they asked to be hanged early in the morning before the country mobs came in to enjoy the fun. Mrs Branch rose early on the appointed day and roused her daughter, saying that if she didn't make haste the mob would be upon them.

The sentence of death was carried out on the appointed day. Upon leaving the jail the old harridan felt a chill and said to one of the party, 'I have forgot my cloak and clogs, pray fetch them lest I should catch cold.' When they came to the place of execution one of the uprights and the cross post had been cut through and carried away, probably by vandals, whereupon Mrs Branch, somewhat appropriately, asked to be hung from a tree to get it over with, but the gallows was soon repaired. After brief speeches in which the mother still insisted that she never intended to kill the girl and the daughter begged the crowd to pray for her, the two prepared to meet their end.

Elizabeth gave her cloak to Hannah Merefield, who had kept out of the way during the trial to avoid giving evidence against her and must have been one of her few friends. Then, bizarrely, she 'helped to settle the halter on her daughter's neck'. She asked the jailer for a dram, which he refused on the grounds that she'd already had two, which he thought was enough. Her own halter was then fitted and the block removed from under them. They hung for about three quarters of an hour before being taken down and were buried in Ilchester churchyard.

In the contemporary pamphlet there was a PS: 'It now comes out for certain that the deceased went to Faulkland for the bran but not carrying money for it, Margaret Budd would not give Mrs Branch credit and so the poor girl became an innocent victim of her mistresses fury.'

See also *Frome Society Yearbook* 9 (2004), pp. 63–68, for a transcript of an eyewitness statement by Ann James reproduced from the Somerset Record Office document DD/X/WI 37.

4. A PARISH CONSTABLE'S TALES

The office of parish constable is an ancient one dating back to medieval times. The appointment was made each autumn, which in Frome took place at the George Inn in the Market Place. Candidates were chosen from among the principal inhabitants of the town and they initially served for one year. The office was part-time and unpaid, but the constable could claim expenses. The constables were assisted by 'tithingmen' or petty constables – one for each of the three divisions of the parish. To further assist in their duties they had use of the stocks and two lock-ups. One, known as the Guardhouse was next door to the Blue Boar pub. It was built in 1725 and sadly demolished in1965. The other, referred to as the Blind House because of its lack of windows, still exists and can be found in the north-east corner of St John's churchyard. This was built in 1798.

Isaac Gregory held the office twice; initially from 1813 to 1814 and then again from 1817 until 1818. He was a currier or leatherworker by trade, with his own business, and lived with his wife Elizabeth in Cheap Street. It is difficult to see why anyone would take the job of parish constable, as it was a thankless task with constant threat of personal injury. There was also no reward, and one was more likely to lose friends rather than make them. On one occasion, while evicting a troublesome group from the Ship one of the party informed him that his actions had just lost him £20 worth of business in the leather trade. At other times he returned home beaten and bloody, having sorted out some fight or other in a pub or the Market Place. He kept diaries throughout his terms in office, which show a great deal of humour, human understanding and fairness, but not perhaps a great belief in the emancipation of women – a man of his times indeed.

The guardhouse demolished in the 1960s. (Courtesy of Frome Museum)

Above: Cheap Street, Frome. Home to Isaac Gregory.
(William Wheatley)

Left: An old-time parish constable.

Gregory died in Frome on 13 September 1835 at the age of fifty-eight, leaving his wife and two daughters to carry on the leather business. His wife lived on until 1844. The diaries passed through various hands before a copy found its way to Frome Museum and then to the Frome Society for Local Study where they were edited and prepared for publication by Mr Michael McGarvie.

The duties of a constable were many and varied, almost all involving the keeping of the peace – not infrequently between husband and wife.

25 July 1814

Received a report that a pensioner had murdered his wife in Broad Street, Frome. Went up in great haste pondering in our minds the awful scene we were about to witness. When we arrived at the house we heard to our great joy the supposed murdered woman speak, and she spoke very fluently too. She wished us to take her husband into custody as he had nearly killed her and would have quite done it had not the neighbours extricated her from him. I told her she did not appear like a person that had been so well used, and that she herself ought to be confined in the guard house herself for alarming the town in the manner she had done. She then uncovered herself and showed by the marks she had about her she had been handled roughly.

I asked her the cause of the quarrel. She said 'I will tell you the truth sir. My husband is a pensioner and he bin and took his penshin money and bin out drinking all day, and I bin out tonight and had a glass of beer myself with a friend, and he come home first and because I wasn't at home to get his supper for him he began beating me in this manner and he have broke everything in the house to pieces and he will murder me quite if you do not take him to the guard house.'

So for her story. I could not pay attention to her any longer. Told her she was a bad woman or she would not have been drinking at this time of night. She ought to have been at home and provided for her husband in the way he wished her. She did not relish it at all, 'I went into the house and all was confusion and wreck. Pans, plates, cups and saucers, dishes pots and everything of the pottery kind was broke into a thousand pieces.'

The man was lying on the bed with his clothes on. I asked him what was the matter. He coolly said 'Nothing at all sir!' 'How can you tell me that? See how the broken things are scattered in every direction.' He said very dryly, 'what you see broak is my own property and nobody's else, and I have a right to do as I like with my own property'. 'But you have been using your wife ill.' He said 'I have not used her half as ill as she has used me, not a quarter as much as she deserves.' 'But haven't you been out drinking all day?'

'No sir, I have been out mowing all day and when I came home I expected to have my supper cooked for me. Instead of that there was no fire nor candle nor victuals, nor anything else and the dirty bitch have been out drinking with a parcel of fellows till a bit ago and when she came home to bed she began

abusing of me for not giving of her more room, and she have bit my finger through with her teeth, which made me force her out of the house.'

I looked at his hand, and behold, she had murdered his finger with her teeth! I saw in amazement she was the worst of the two and said, 'Woman, you have confessed to me that you have been drinking at a friend's house. If you can get lodging there till the morning, I do insist upon it you do go as your husband forced you out of the house to prevent further mischief and then you may make your complaint to the magistrates.'

A lot of Gregory's work consisted of calming fights and throwing drunks out of pubs – often at some risk to himself. And it wasn't always the customers that took umbrage, as these little tales show.

5 December 1813

Sunday Evening. Went with the other constables to the public houses to turn out the persons found drinking There was many men at most of the public houses in the lower part of the town. I caught my own apprentice at the [Black] Swan over the bridge and gave the landlord a reprimand for his conduct. Mr Butcher's wife was extremely saucy – said she would give a person two or three quarts of

Entrance to the lock-up in St John's Churchyard.

The Black Swan in 2018.

beer at any time she thought proper. I told her if ever I was insulted so again I would report it to the magistrates but she would not keep her saucy tongue still although insisted upon by her husband. What an affliction to a man to have such a wife. Her tongue may someday prove his ruin as he seems to be mastered by her, 'And the Lord said unto Adam, because thou hearkened unto the voice of thy wife, cursed is the ground for thy sake.' I see more than ever the great importance of a man ruling his own house and I am determined never to give up the reins to a female except it is for my amusement – a few minutes now and then just as a cat would let a mouse go, but having the eye fixed to seize it in a moment.

10 December 1817

A violent outrage on my person. Was sent for in a great hurry to the Eagle at 10.20 at night, on my arrival found the watchman contending with a man by the name of Jas. Biggs of Mells – the fellow that stole Mr Cox's figs He was in a dreadful passion and swearing that he would not go to the guardhouse.

I learnt from Mr Williams the landlord that he had been very abusive because he was denied beer after ten at night which induced him to put him in charge of the watchman till I was sent for. I insisted that he should go peaceable to his home and with the help of the watchman forced him a considerable way but his

resistance was so powerful, and being nearly spent, I was determined that he should go to the guardhouse.

On the way down he gave me a violent blow in the face which almost stunned me and endeavoured to make his escape. On recovering myself I attacked him with my staff and made the watchman do the same which tamed him a little but we was obliged to drag him by main force into the guardhouse. I found when I came home my face was badly bruised and my eye was getting black. I had injured my watch and one of my fingers was very bloody. I was greatly enraged and gave in my deposition the next morning and took him to Orchardleigh, being determined to send him to prison.

Mr Champneys was in his Park and said we must take him back and bring him up again tomorrow for he would not give up his amusement. I told him the prisoner was at his house and everything was ready for his signature but nothing would do and I was obliged to return the following day extremely mortified at the injustice of a justice.

Biggs was a great penitent and his wife repeatedly came in tears to beg me to forgive her husband which I was somewhat disposed to do as I was shamefully

Orchardleigh, where Magistrate Champneys held court. (Courtesy of Michael McGarvie)

treated at Orchardleigh yesterday. Therefore I took him over to Champneys and after he had a severe reprimand I withdrew the prosecution on his paying the expenses and publically advertising himself, which advertisement I drew up as follows:

Caution to Drunkards

Whereas I, James Biggs labourer, did, on the night of the 10th instant violently assault Mr Isaac Gregory one of the Chief Constables of Frome while in the execution of his duty, and did, (being in a state of intoxication) give him a violent blow to the face for which he commenced an action against me that I may be punished with the utmost severity of the law, but in consequence of my publicly acknowledging my offence, and begging for mercy and in compassion to my wife and child, has withdrawn his prosecution against me I hope it will be a caution to me and all drunkards not to interrupt the police officers in the execution of their duty.

Witness my hand in the presence of TS Champneys at Orchardleigh. X the mark of James Biggs.

20 July 1814

A bloody battle at the George between two weavers. Found them fighting in a back room. My appearance put an end to it. The working people are determined to give more than five pence per quart for strong beer, and the George is the only

Frome Market Place, *c.* 1860.

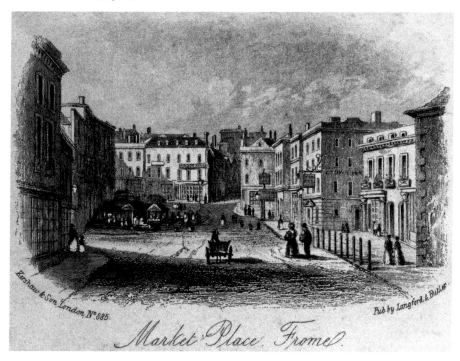

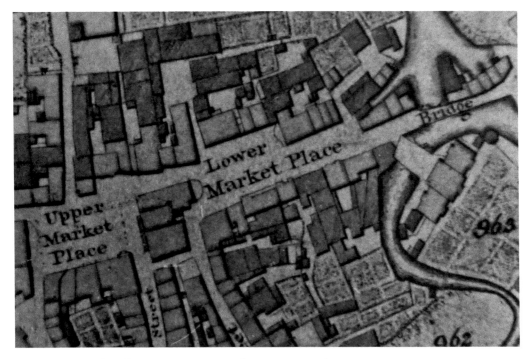

Frome Market Place, 1813. (Courtesy of Frome Museum)

place in town that sells it for less than sixpence which causes a great influx of blackguards to the house. How long it will last I cannot tell but I am inclined to think they won't have many of the Nobility while they have their house crammed with so many of the Mobility

1 April 1818
Wednesday and a full market. A severe battle for a long continuance in the Lower Market. The farmers enjoyed it so much they would not send for the constable. I learned it from one of the market women, what was going on. On my arrival I found each fellow had received some severe blows, a man in passing struck the others cow on the horn which was the cause of the battle. Very serious things often arise from trifling causes, the above is an instance of it.

Frome has a well-earned reputation for looking after its own business and not being overly concerned with national events but things were a little different in April 1814 when news was received that Napoleon Bonaparte had abdicated the throne of France.

News is arrived of Bonaparte abdicating the throne of France. All is mirth and jollity in the town on the account and the lower orders of people are getting drunk. I have my fears they will get riotous but the least notice is taken of them the better unless they carry their insults too far. Mr Pitt have had Mr Bonaparte swinging from his garret window preparatory to his being burned.

15 April 1818

A bonfire in the Market Place. Bonaparte committed to the flames. He burned remarkable well and gave plenty of amusement to a numerous company of spectators. Instead of black the people generally wore white.

18 April 1818

A Grand Illumination in the town, the finest ever remembered. Each seemed to do his utmost to exceed his neighbour. All was gaiety and cheerfulness, I never saw the town so full of people to the best of my recollection. Al the surrounding villages must have been deserted at the time or we could not have had such an influx of people.

As well as subduing drunks, supervising jollifications and philosophising about a woman's place, there was crime to contend with.

22 April 1814

Francis Warden, shoemaker of Chapmanslade, was delivered into my custody under a Justice's Warrant to be conveyed to Ilchester Gaol charged on the oath of John Backhouse with having stolen a quantity of leather out of his tan yard

The George Hotel, Frome Market Place, 2012.

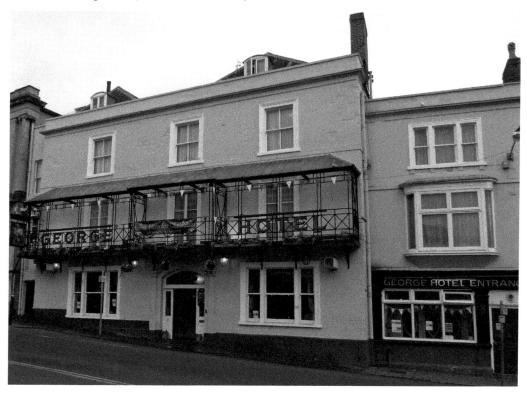

The Ship Inn, now the Artisan.

to the value of five pounds. I had many cautions from different people to be on my guard as he was known to be a desperate fellow. Mr West (one of the tithingmen) agreed to start with him at one o'clock in the morning and I said I'd stay up to that time to assist him. We handcuffed his hands close together before he left the guard house and marched him up to the Ship where we hired the gig.

As I was assisting Mr. Tabbutt in putting him to the horse he suddenly darted away from West. I flew after him but found he was like myself – a swift runner. He run up Badcox through Long Row up to Nail Street. He then made a double as I was close upon him and ran down towards Whittocks Lane. Here I overtook him. He again made another short turn and a desperate effort to escape and get back into Long Row again where I overtook him an gave him a severe blow with my staff which made him submit. I so outran West that he was not within hearing till I got him back into Long Row again. We then got him back of the Ship and chained his legs together, but West stayed with him until daylight fearing he might have some accomplices who might try to rescue him. I should sooner have lost fifty pounds than he should have got off as I should never have

Whittocks Lane where Gregory chased Francis Warren.

heard the last of it by my joking friends. I have learned a lesson from this fellow not to be to confident of my own exertions for had he not been handcuffed I have no doubt that he would have got clean off.

13 December 1817

Brother Samuel's foreman came to me at eleven at night to say that his shop mate had broken open his box and stolen from 12 to 20 pound of his money – he was not at home after he had committed the robbery, they thought he was at Clink with his sweetheart and earnestly begged that I would go with them. I did not think it right to refuse so away we went. It was very dark and dirty.

Before I got to Clink I put my light out to prevent discovery but it was so dark and muddy we could not get near the house without a light, therefore one of my assistants broke over a hedge where he saw a light in a window to obtain a light for the constable- the people thought he had been a robber and was in great fright. I sent a second person to demand a light for the constable but this increased their fears. I then got to the house myself but could not remove their fears for a considerable time.

After obtaining a light we made towards the house were the fellows sweetheart lived, the first person I saw in the room was the man himself, he

and all the house was astonished to see the constable brandishing his staff at the head of five men. I immediately charged him with having knowledge of the robbery which he denied. I ordered him to put the money out of his pockets which he set about but in so lazy a way. I searched them myself, the first dip I recovered £1/8/8d of the property which set everything beyond a doubt that he was the robber. He then put his hands behind him as if he was going to pull off his coat, but seeing his fist clenched I forced his hand open and found £3 in notes in his hand which the foreman said he would swear was his.

I then took him into a room and told him that his offence was a capital crime and if he expected mercy he must give up the property he had stolen. He then confessed his crime and gave up three handkerchiefs, two pairs of stockings and a hat which he had just purchased with part of the money and offered to make good the remainder of the money which he had laid out – he was in great distress and the foreman dreaded to have him confined as he should be obliged to prosecute and it would touch the fellows life – all he wanted was to get his money back and so he forgave the man. Returned from Clink at quarter past twelve, completely bespattered, but was highly gratified with the success of the enterprise.

Extracts are taken from *Crime & Punishment in Regency Frome*, edited by Michael McGarvie (Frome Society for Local Study: 1984).

5. THE MURDER OF WILLIAM WEBB AND MARY GIBBONS

On the evening of 28 December 1812 William Webb, a fifty-five-year-old bachelor farmer, was at home with his servant Mary Gibbons, sitting in front of his fire while the snow piled up outside at his farm in Roddenbury Hill, between the Corsley and East Woodlands just on the Somerset side of the Wiltshire border, when there was a knock at the door. It was opened to George Carpenter, a twenty-one-year-old labourer who said he was looking for work despite the land being frozen over and covered in snow. 'Ah! You rogue!' said the farmer in jest, 'You don't want work, 'tis only an excuse for a jug of cider, fetch him a cup Molly.' 'Thank you sir,' replied Carpenter, 'but here is Ruddock at the door.' 'Is he?' replied Webb, 'then we must have a larger mug my maid.' Webb invited the two young men to join him by the fire, but as he did so Carpenter beckoned to his twenty-year-old companion George Ruddock, who stood by the door, offering him the same hospitality. Ruddock declined it, saying that he must go home for his supper, while at the same time discharging his weapon at the farmer, which at first misfired but was discharged at the second attempt. Webb was peppered with shot but not subdued, causing the pair to beat him severely round the head and face with the butt of the gun and a wooden flail lying nearby with such brutality that parts of his skull were forced into the brain.

A threshing flail similar to the murder weapon.

Upon hearing the disturbance Mary Gibbons attempted to escape but was overtaken by Ruddock, who knocked her on the head with his gun, bringing her to the ground, in an effort to do away with any witnesses to their murderous crime. The poor maid was then dragged towards the well and, while Carpenter held the cover open, Ruddock threw her head first into it, saying that she would not be found for some time. Some accounts say that her throat was cut while others that she tried to save herself by clinging to the lip of the well but the two ruffians chopped her fingers off with a hatchet; both accounts agree that she was alive at the time as they heard her groan.

The murderers next went through the pockets of the poor farmer in a search for his keys and pocketbook, then they ransacked the farmhouse and left with a quantity of property and banknotes. Their mission completed, the pair left the scene and went to their respective homes, hiding the gun in a potato pit on the way. The next morning Ruddock called on Carpenter and retrieved the gun and buried it in a nearby wood before going off to work at a neighbouring farm. As part of their haul they had four banknotes, which they divided between themselves, along with silver and some gold coins, which they buried at various sites in the wood. A reward of £200 was offered for their detection and conviction.

Webb's body was discovered by Susanna Gibbons, sister to Mary, after it was noticed that the shutters had not been opened for some time. The body was examined by Joseph Miller, a Frome surgeon, who reported that it contained a great many pieces of shot particularly in the right arm and chest region but that death had been caused by many blows to the head and face, which was dreadfully fractured. News of the murders spread fast and on 30 December it was talked about at every farm in the area, including that of Mr Battle where Ruddock and Carpenter worked. They were thrashing corn and talking to their master on matters of no consequence when the mistress came running out to give her husband the news for the first time. The two labourers continued at their work without stirring or expressing the least surprise. Carpenter left that job shortly afterwards and took up employment nearby – part of his wages included beer with the family at the farmhouse. On 26 January, conversation turned towards the recent murders and the farmer's wife said, 'I pray to God that those who did that murder might be discovered and undergo their most just punishment.' Carpenter trembled, turned pale and did not enter the farmhouse for his beer again.

If his guilty conscience was not enough to give him away, his ignorance and indiscretion certainly was. Over the next few weeks he attended an auction of the farmer's effects, and even bid for some himself. The pair of them also went to a church service at Frome in Webb's memory. Carpenter was a farm labourer subsisting on a labourer's wage, but during that month he went into town and offered a £1 banknote to Mr Sinkins, a draper, in Frome Market Place to purchase a new carter's frock coat priced at 12s. The note was damaged in some way and so was refused, causing Carpenter to pull out a £5 note. As he could not read it was obvious that he believed this note to be of the same value as the previous

one, immediately raising the shopkeeper's suspicions that it had not been come by honestly. Simpkins allowed Carpenter to take the coat and asked him to return later for his change, which he agreed to do, giving the name William Haines.

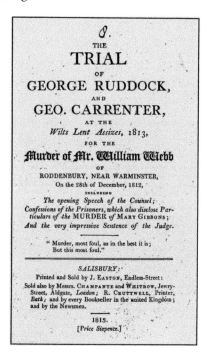

Right: The trial of Ruddock and Carpenter, 1813.

Below: Frome Market Place in the 1880s. (Courtesy of Frome Museum)

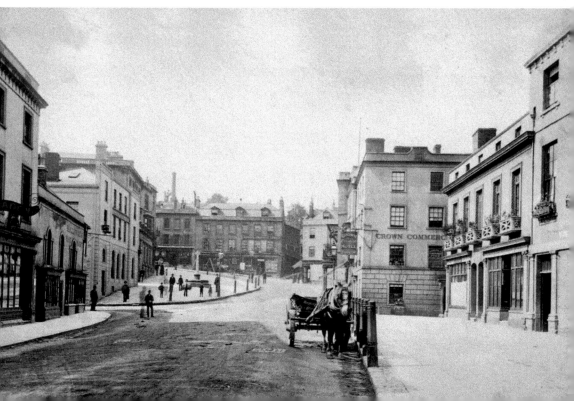

Suspicions suitably roused, Carpenter was apprehended and almost immediately turned king's evidence, making a full confession and naming Ruddock as his partner in crime, who likewise confessed his full involvement. His account differed with some minor details and each blamed the other for the major part in the affair. They were committed to Fisherton jail in Salisbury.

Had they been more cautious they might have got away with it, as another person was strongly suspected. James Udell, otherwise known as David French, a shearman, was already in custody and fully committed for trial by the magistrates.

> James Udell, otherwise David French, who has long been detained in custody on suspicion of being an accessary in the murder of William Webb and Mary Gibbons, after great exertions of the Magistrates, and different examinations, is at length fully committed for trial.

Above: The *Bath Chronicle* of 2 December 1813.

Below: Salisbury Guildhall. (Courtesy of Jonathan Kington, CC BY-SA 2.0)

At the trial, which took place on 8 March 1813 at the Salisbury Assizes in front of Mr Justice Chambre, no evidence was taken in the case of Mary Gibbons as the confession to the murder of Webb was considered enough to convict the two of the capital charge.

They were sentenced as follows:

George Ruddock, and George Carpenter – You have been severally found Guilty, by an impartial Jury, of the Murder of William Webb. The propriety and justice of that verdict, no person living, who has been present to-day, can doubt of for a moment. That is not the only crime with which you are charged - but also another crime of a similar nature against another person. You are not about to suffer for that offence, but it may not be improper to advert to it; because it forms a part of the grounds of the observations I have now to offer. I hardly ever heard of this the greatest of all crimes committed under circumstances of less excuse or greater aggravation – You had received no provocation; You went to the Deceased's house; When you reached the house, he received you with kindness and humanity – and offered you some refreshment which he thought you stood in need of; Instead of accepting it, you proceeded to execute your bloody purpose with deliberate and determined cruelty and barbarity, and nothing can be offered in vindication or mitigation. Murder is the greatest crime of one human being to another. I do not mention these circumstances to aggravate the misery of your present situation – but only to waken you to a sense of your present duty. You have only a few hours to live. Yours is an offence beyond all hopes of mercy. By whom human blood is shed, by man shall his blood be shed also. It is not too late to obtain mercy, where, for persons found in your situation, mercy may be found. Your duty is to endeavour to obtain that mercy – and it is not too late to hope to obtain it – but you can only receive it by such conduct as I have mentioned. You will before the awful period be assisted with every kind of spiritual advice to console you in making that kind of peace and atonement. I shall say no more but leave it to better advisers to put you in the right way.

All I shall do is to proceed to pass the dreadful Sentence of the Law – and I accordingly pronounce that Sentence, which is: That you be taken to the Place from whence you came – from thence to the place of Execution on Monday next – there to be hanged by the neck till you are severally dead. Then taken down, and delivered to the Surgeons to be dissected and anatomised, – And may God Almighty have mercy on your souls.

This Sentence drew tears from many present, and the Prisoners appeared to be greatly agitated and affected.

On the appointed day, the pair were brought to Warminster from Fisherton jail in a black coach. At 4 and 8 a.m. on Monday morning, they were conveyed to the chapel where they remained in prayer until 11 a.m, after which they were taken

by cart to Warminster Down – the place of execution. The spot chosen was Arn Hill, 21 miles from the jail. It had an almost perpendicular elevation, standing 500 feet above the town and looked down on Warminster Church, where Mr Webb was buried. It was also very near to the scene of their crime and only two men had been hung there over the past ninety-one years. They arrived at around 12 o'clock to be confronted by what the contemporary newspapers described as a concourse of more than 50,000 spectators. They then spent another hour and a half in prayer. As one contemporary account put it:

> They were both suitably affected by the horrors of their awful situation; but Carpenter displayed less fortitude and his companion in guilt. The friendship which had been cemented by the blood of the innocent victims appeared to be quite dissolved for they did not even exchange a parting farewell and were forced as it were, unresigned into the presence of an offended God.

The order of the procession of Ruddock and Carpenter.

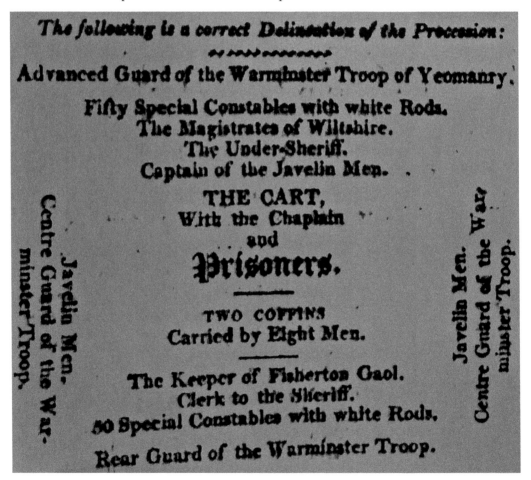

The pair were bound and standing on a cart. A handkerchief was given to Carpenter, who was supposed to drop it once he had composed himself as a signal for the cart to be drawn from under them, but such was his fear that he delayed dropping it for nearly half an hour, begging earnestly for a few minutes longer. Even then he endeavoured to avoid the fall for as long as he could, thereby suffering greatly, whereas Ruddock jumped boldly from the cart when it moved and was dead in a moment.

 As was the custom at the time, the bodies were taken to Salisbury for dissection. The right arm of George Carpenter survived into modern times, being donated by local surgeon Dr Charles Kindersley to Wiltshire Museum in 1938, after which it passed to Cribbs Funeral Directors for a proposed National Funeral Museum in 2005.

Ipswich Journal, 1813.

Early on Monday morning, Ruddock and Carpenter, the murderers of Mr. Webb and his servant, were removed from Salisbury gaol, to Warminster, in a mourning coach, attended by the usual escort of javelin men, &c, preparatory to their execution on the Down, close adjoining to Warminster. The spot chosen for this purpose was the point of an almost perpendicular hill, 500 feet above the town, looking down on Warminster church, in which Mr. Webb was buried, and nearly in view of the house where the murderous deed was perpetrated. About half-past 11 o'clock the procession began to move from the chapel, in Warminster market place, where the miserable culprits had been from the time of their arrival. After they were tied up, a handkerchief was given to Carpenter, to drop it as a signal for the cart to be drawn from under them; the poor wretch, however, clung so to life, that he delayed dropping it for nearly half an hour, begging earnestly for a few minutes longer; at length he dropt it, but, even then endeavoured to prevent his fall as much as he could, whereby he suffered greatly in dying: whilst Ruddock, who jumped boldly from the cart when it moved, was dead in a moment. The murderers made no confession of any importance subsequent to their conviction; indeed, their first confession was so ample, that it admitted of but little addition; they were to the last much exasperated against each other, each condemning the other for the disclosure of their bloody deed.

6. THE MURDER OF SIR CHARLES BAMPFYLDE

Charles Warwick Bampfylde was born in January 1753. Despite being from an ancient family based at Poltimore in Devon, the family had owned a large part of the village at Hardington Bampfylde, 5 miles to the north-west of Frome, since the fifteenth century and built a large manor house there. Bampfylde soon acquired a reputation for enjoying the pleasures of the gaming table and alehouse and was often portrayed as a dissipated and extravagant young man who became an associate and drinking companion of the prince regent at Carlton House.

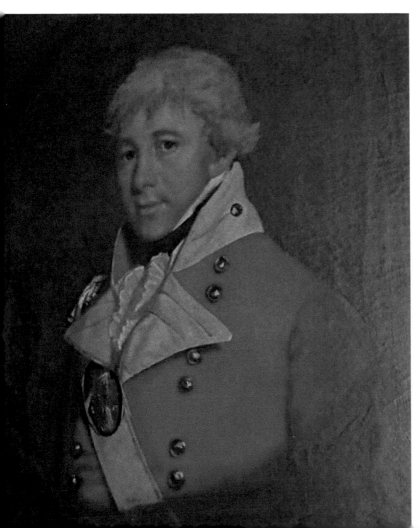

Sir Charles Bampfylde. (Courtesy of Everett Fine Art)

Sir Charles succeeded to the baronetcy in 1776, becoming the 5th Baron upon the death of his father, and served twice as MP for Exeter – from 1774 to 1790 and 1796 to 1812. His attendance was best described as irregular, and after his election in 1780 the *English Chronicle* remarked:

> Before he succeeded to his estate, though scarcely twenty-five years of age, he had spent nearly two-thirds of it … Plundered by the most usurious contracts, and defrauded by every degree of rapacity and injustice, even reduced to the last extreme of necessity, Sir Charles Bampfylde has preserved the character of a fair and honourable man, and given a striking instance that the pride of an English gentleman, though it may reduce him to misfortune, will ever keep him above meanness … it is not likely that he will now change his political principles, since he has suffered all the consequences of the follies and extravagance of youth, without discovering any inclination to be converted by the prospect of relief from political apostacy.

Despite, or very possibly because, of his rakish reputation, Sir Charles seemed well liked and was described as being of dashing appearance, splendid equipage, and ingratiating manners. Neighbour and contemporary Revd John Skinner had little time for him, saying he did not believe there was a more worthless fellow in the west of England and that he laughed at all things serious, but then Skinner didn't have much time for anyone.

Sir Charles eventually settled down and acquired a family, spending much of his time in London despite his connections to the West Country. He became High Sherriff of Somerset for the year 1820–21, during which time he successfully took up the cause of Henry Hunt. Known as 'Orator' Hunt, he was a leading radical imprisoned in Ilchester jail and had been denied all visits from his friends and relatives, as well as most of the usual privileges.

On the afternoon of Monday 7 April 1823, a thirty-seven-year-old footman named Joseph Morland called at No. 1 Montague Square, the London residence of Sir Charles, and demanded to see him. The servant who opened the door told him forcefully to go away. Morland tried to force his way in, and the servant had to call for assistance to have him removed. Morland was the husband of a woman who had been employed by Sir Charles as a housekeeper for the past eight years and had been making a nuisance of himself, calling frequently at the house and creating a disturbance. Morland went down the road and asked Lucy Stockes, a woman with a fruit stall, if she had seen Sir Charles that day. The woman had scarcely replied in the negative when Sir Charles appeared.

Morland drew a pistol from his coat and shot his victim in the side. Almost before he had fallen, Morland discharged the second pistol into his own mouth, the ball passing through his head and killing him instantly. Although then seventy years of age, Sir Charles managed to stand and, stemming the wound with his handkerchief, managed to get home.

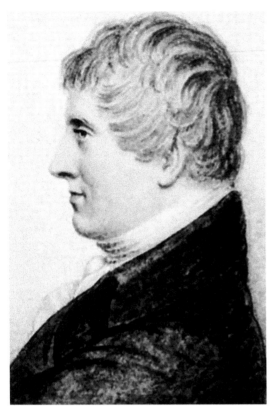

Left: Henry 'Orator' Hunt.

Below: Montague Square today.
(Courtesy of Andy F., CC 2.0)

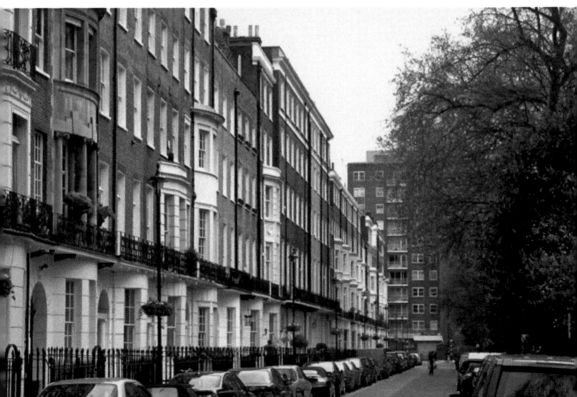

DREADFUL ATTEMPT AT MURDER AND SUICIDE.

As Sir CHARLES BAMPVLDE was passing along Montague-square, about half-past four yesterday evening, he was shot at by a man, who immediately drawing another pistol from his pocket, placed the muzzle in his mouth and blew the upper part of his head away. His body now lies at the Westmorland Arms, George-street, Manchester-square, picked up by Tom Jones and a man of the name of Johnson. The ball entered Sir Charles's side, but supposed not to be mortal, as he was enabled to walk home, stemming the blood with his hanker-chief. Jealousy was the cause.

Above: Report in the *London Morning Post*, 8 April 1823.

Right: The former Worcester Arms.

The body of Morland was conveyed to the Worcester Arms public house in Portland Street where it was locked up to await the coroner's inquest. More than one contemporary newspaper reported that 'jealousy is said to have been the cause of this dreadful affair'.

The following day, Tuesday 8 April, an inquest into the death of the assassin was heard at the Worcester Arms. Crowds of individuals filled the passage, and there were so many that the coroner, Thomas Stirling, had difficulty gaining entrance and had to order the room to be cleared.

Fruit seller Lucy Stockes deposed that her husband Thomas had been a coachman to Sir Charles and that she had worked as a charwoman in his house and now sold apples on the corner of the square. At around 4.30 p.m. on Monday, she had heard the report of a pistol and someone exclaim, 'Oh!' Followed almost immediately by the sound of a second pistol. She saw Sir Charles moving quickly towards his house and asked what was wrong, to which he replied, 'That damned rascal has shot me in the side!'

She stated further that Morland's wife had been housekeeper to Sir Charles but had been living with another family, and that Morland had made frequent inquiries about Sir Charles over the past three weeks. She believed that Sir Charles had caused the deceased to be taken before a magistrate some time since on account of some outrage on a footman, and that he was hoping evidence would not be given against him and he sought to persuade Sir Charles to get the case dropped. Morland stated that he must see him. Stockes added that Morland had never worked for Sir Charles as a servant.

Thomas Elliot said he had been going down George Street when he saw the deceased, then wounded, in the arms of some people who carried him to the Worcester Arms. He was quite insensible and continued so until he died about five minutes later. Mr Armstrong, the surgeon, was sent for to attend upon the deceased and found him lying on the table in the tap room. He was quite dead; there was no pulse and he had been shot through the roof of the mouth. He was convinced from the magnitude of the wound that the deceased had shot himself and that the mouth of the pistol had been very close to the wound.

There was a letter taken out of Moreland's pocket, which was put into evidence and read to the inquest. It was to his wife, dated 23 March, and began by stating that the expense he had been put to by the prosecution, which had been instigated against him by one of the servants in Sir Charles' house, had exceeded £3 and blamed his wife and her master for urging the matter on. He also considered by her conduct that she endeavoured to shun him, which raised strong suspicions in his mind. He concluded by saying that if his suspicions proved groundless he was willing to live comfortably with her again, or if not they should separate.

The errand boy William Hayles saw the two men side by side and heard reports of two pistols, noting the second in Morland's hand with his arm listed and his arm pointing towards his face. A passing butter man picked up the first pistol and left it at one of the houses; the second was taken to Sir Charles' house. Hayles saw Sir Charles put his hand on his back towards his side and walk towards his house.

Richard Watchome of George Street deposed Morland had lodged at his house for around six weeks and always conducted himself in a proper manner. He last saw him on the morning of the incident at the Westmoreland Arms in George's Street and wished him good morning; there was nothing singular in his conduct at that time. The brother of this witness, landlord of the Westmoreland Arms, where the deceased was staying, deposed he had frequently heard him mention

his embarrassment that he could not accept an offer of employment because there was an indictment against him arising from the malice of his wife due to an affray that had occurred when he went to see her. It seems that Sir Charles had a cask of ale brought from his country house and that Morland was anxious to partake of it, but his enthusiasm was resisted by the butler and the footman, leading to the assault.

Morland stated that he had kept a public house in the country and that Sir Charles had advanced him two sums – one of £100 and one of £60 – and that he had been 'unfortunate' and the business had failed. On top of this it seems he did not have the money to pay his lawyer to defend him against the affray charge and complained that the people at Sir Charles' house would not let him see his wife so he had written to her asking her to persuade Sir Charles to drop the prosecution and wished her to at the very least sign a deed of separation, as it was his belief that she and Sir Charles had been having 'criminal connection' for some years. The jury said they were of the opinion that Morland believed his wife was having 'connection' with the victim due to the contents of the letter. It was his intention, he claimed, to subpoena Bampfylde for the trial, which he must win or be ruined and lose his character for ever.

The coroner, from all that he had heard, was convinced the deceased was quite sane when he committed the act and the jury, being of the same opinion, found a verdict of *felo de se* – death by suicide. The inquest was not over until nearly midnight. As regards Sir Charles, a statement on the nature of the wound was issued by a number of medical professionals:

Sir Charles Bampfylde has been wounded by a pistol ball in the right side of the chest, which entered below the shoulder near the spine and has lodged. The wound is not a present attended by any unfavourable symptoms but it is still one of a very dangerous tendency.

On 17 April, a further bulletin announced:

Sir Charles had had more pain during Saturday night than hitherto and was not in quite so favourable a state as he had been for the past three days. The Ball is not yet extracted.

Two days later a final statement was issued,

Sir Charles Bampfylde who was shot about a fortnight since by Joseph Morland died on Saturday night at 8.20 on 19 April. The surgeons having been unable to extract the ball had on consultation pronounced his case hopeless. For some days he had been in a state of torpor and expired in that melancholy situation.

The coroner's inquest was held at the request of Bampfylde's family 'in order if possible to elucidate any further circumstances which could have led the assassin,

Morland, to the commission of the diabolical act; and as various unpleasant rumours were circulated in the neighbourhood it was thought necessary to adopt this course even though the body had been soldered up'. There is mention in the report of the jury viewing the body, so presumably the lead lining had been de-soldered for the occasion.

This inquest had very little to add about the circumstances of the crime that had not been discussed previously. If the aim was to dispel 'unpleasant rumours', the way of doing this seems to have been by not mentioning them at all. And when the jury asked if they could see the letter the coroner 'fudged' the issue, saying he did not know who had it and made the rather sweeping statement that whatever was in it 'the contents could not justify any man shooting another'. The exact reasons for Moreland's actions remain unclear; either he believed that his wife and Sir Charles were having an affair, or he was driven to distraction by the thought of the impending court case, which would ruin him. Undoubtedly, Bampfylde's reputation had fuelled the former, who must have been suffering from a very depressive episode.

As to the cause of death: Sir Charles was initially composed, free from fever but with a very quick pulse, and was seen standing in his dressing room with a wound 3 inches below the shoulder blade on the right-hand side of the back. He had been ordered to bed and told to keep quiet. He complained of great pain from the wound to his left side, the ball having entered between the ribs. Despite the odd rally his condition worsened, resulting in his death. A post-mortem was carried out, which showed that death was caused not so much by the pistol ball but by a piece of brass wire that was carried into the wound along with the ball, the wire having formed part of the spring of his braces. Every attempt to extract it proved abortive; it corroded and gangrened within the wound and ultimately produced mortification. The doctors issued a final report:

> The ball had entered on the right side between the eleventh and twelfth ribs, fracturing the articulation of the former with the spine and then passed across, grazing the diaphragm or floor of the chest, but not injuring the lungs, and lodged on the inside of the anterior part of the cavity, between the ninth and tenth ribs – a part of the ball was uncovered and visible from the inside.
>
> H. Ainslie MD; J. Heaviside, GJ Guthrie; P. Macgregor; J. Howship.

SIR CHARLES BAMPFYLDE.

CORONER'S INQUEST.—Yesterday an Inquest was held on the body of this universally lamented Gentleman, but nothing in addition to the facts already published, was adduced in evidence. The main questions put were by the Foreman, Sir W. K. GRANT, to the Professional Gentleman who first attended the deceased, viz.:—

Q. Pray was there any other substance found in the wound than the ball?—A. Part of his flannel jacket, which was immediately removed.

Q. Did the deceased at any time state how the wound was occasioned?

Witness—Yes, Sir, he did; he said that there was a prosecution for an assault pending against Morland by his (Sir Charles's) servants, and that Morland came up to him, and asked him to forego the prosecution, and that Sir Charles said he would not have any thing to do with him, and told him to go about his business; that he Sir Charles then felt a pain at his back, as if by a violent blow from a stick, and that on looking round, he then saw the murderer bleeding at his mouth, and then Sir Charles concluded, that he himself had been shot.

After the usual formalities had been gone through, the Jury returned a verdict—"That Sir Charles Bampfylde, Bart. was wilfully murdered by Joseph Moreland, deceased."

Above: *The Morning Post*, 8 April 1823.

Right: Arms of the Bampfylde family.

7. A SETTLING OF ACCOUNTS?

THE MURDER OF URIAH GREENLAND, 1861

On Monday 12 August 1861, as the clock struck noon the doors to Frome's newly built police courts were thrown open, causing a rush of people towards them, but only a few managed to gain entry to the small court. In front of them was a bench of four magistrates. In the dock, towering above them at over 6 feet tall with a strong build, stood the prisoner: Byard Greenland, a thirty-one-year-old labourer from Buckland Dinham charged with the murder of his nephew, Uriah Greenland, aged twenty-three. Soon after, despite the non-appearance of Greenland's solicitor, the case opened and the first witness was called.

William Millgrove, a labourer from Buckland, gave evidence that on Saturday 10 August he, Uriah Greenland and Byard Greenwood, Uriah's uncle, were returning home from Codford to Buckland Dinham (a distance of around 20 miles) after spending the previous week – from Monday 5 August – bringing in the harvest. At Warminster, they were picked up by a brewer's dray driven by Giles Whittington, a neighbour of theirs, and taken to a pub called the Black Boy at Corsley where Uriah, who was a parish constable, got involved in trying to

A Victorian harvest scene.

stop an argument among some locals. He was knocked down a couple of times before the party managed to escape. At around 9.30 p.m. and with money from the harvest in their pockets, they moved on to a pub called the Live & Let Live on Portway in Frome where they drank beer until about 10.45 p.m. Whittington dropped them by the Lamb Inn at the top of Gentle Street and they set out to walk the remaining 3 miles to their homes in Buckland Dinham. The witness said that although they'd had a drink, they were perfectly sober.

During the journey, as they approached the turnpike on Coal Lane, Murtry, Uriah said to Byard, 'You might as well put the reckoning to rights,' meaning that he should sort out their various small expenses from their time away, including train travel and food expenditure. It seems that the pair had paid towards Byard's fares and upkeep. They agreed and laid their scythes and reap hooks down beside the road to sort the money out. It seems a strange time to do it – by the roadside in the dark, when all three only lived a short distance up the road, but that is what was agreed nonetheless.

Byard claimed that the Uriah owed him 18*d* for some damage done to a gun and would not hand him any money until that matter was resolved. Uriah agreed and there seemed to be no argument between them, but suddenly Byard lurched

The Live and Let Live, Portway, Frome.

towards Uriah, who fell back onto the road, exclaiming, 'Oh Bill! He has been and hit that knife into I!' Millgrove did not see a knife, however, despite only being around 2 feet away from both parties. He picked the injured man up and laid him against the bank, saying to Byard, 'Thee has been and done it now then,' to which Byard replied, 'Canst thee swear that Bill?' 'I can,' replied Millgrove.

Millgrove then ran down to the turnpike gate, around 200 yards away, and began hammering on the door to get help. James Gane, the toll collector, ignored the knocking at first, believing it to be drunks. Millgrove returned to the scene and asked Byard to go himself to the tollhouse and try to raise Gane, which was also met without success. Millgrove then tried a second time and at last succeeded in awakening the household, and the tollkeeper went with the labourer to see what he could do. At the scene he found Byard cradling Uriah, his arm around his neck, and felt for his pulse. He could not find one. Byard asked, 'Do you think he's dead?' To which the tollkeeper replied, he was certain. Millgrove then set off for Frome to find a policeman and Gane returned home to fetch his daughter, leaving Byard alone with the body.

When they returned Byard asked them to examine the scythes, which were encased in wooden sheaves, and the reap hooks, which were bound with straw. One scythe had a point projecting from its cover, but there seemed to be no blood upon it. Byard said to Gane, 'I had those [two] scythes on my shoulder and Uriah ran against them.' The tools were collected up and taken to the tollhouse, leaving the body where it was.

At Gane's suggestion, Byard went home to explain what had happened and to find Uriah's wife, Elizabeth. As Greenland explained in his defence to the magistrates: 'He [Gane] went away and came back again and persuaded me to go and tell his wife and father. I went on home as fast as I could. As we live both together I tried my own door first. I didn't find no one there and I went and called at Bailey's and I said, "Is Jane there?" and he said "She is", I said, "Tell her I want her. Uriah has been and fell up against my scythe I want you to go and tell his wife".' He was in such a state that he was advised to go to bed in a 'very trembling state,' leaving Bailey to explain the situation as best he could.

Next at the scene of the crime was Dr Benjamin Mallam, the surgeon, who arrived at around 12.10 a.m. to find Uriah still propped up against the bank where Byard had left him. With the help of a lantern held by Gane, Mallam examined the body and found that he had been stabbed through the chest. By now a policeman had arrived from Frome and sat with the deceased while Mallam examined the scythes with a magnifying glass, but he could find no trace of blood. Mallam recruited a local farmer with a truck and hurdle to transport the body to the Globe Inn public house in Vallis Way, Frome.

Uriah's widow, Elizabeth Greenland, was called to the stand. She described her husband and the prisoner as normally very friendly, but said they'd had three serious arguments since their marriage just over two years ago.

The road from Frome and the turning into Coal Lane.

On the first occasion the prisoner attempted to take indecent liberties with me at my house, he pressed me against the wall and put his knee against me attempting to expose me saying that there was no harm done as I was his niece.

She continued that he had pursued her around the house three or four times:

I was afraid to tell my husband at the time but told him afterwards. I feared they would fight and that my husband would get the worst of it as I had heard that he would pull out his knife. I told him if he did not stop I will scream and call the police. The second time they quarrelled it was just about work during which they struck each other and the prisoner kicked my husband and drew his knife. I never heard or saw the prisoner threaten my husband's life but I saw him beat him when they quarrelled the second time in consequence of which my husband had a summons against the prisoner on 29 April but it was never signed and the quarrel was made up after them not speaking for two or three days. The prisoner and his wife Jane entreated us to make it up and we did so. Byard paid the 2s cost of the summons and swore that he would never insult either of us again. On the morning after the third quarrel my husband went for PC Millward and when he arrived the prisoner had a bayonet which he was thrusting into a wall, he was intoxicated at the time. This incident was in connection with the first

one, the prisoner continued to attend the house and Elizabeth asked that Uriah request him not to and had to explain why whereupon Uriah had confronted him. We lived about 20 yards from the prisoner and when my husband left to go reaping I begged of him not to work with Byard.

Despite this last statement the witness described them as being 'like brothers'; indeed, Byard was only eight years older than Uriah and they lived next door to each other and would have known each other all their lives.

John Millward, police constable at Buckland, deposed that he had apprehended the prisoner at around 12.45 a.m. at his home. Greenland was partly undressed when the PC found him – possibly changing his clothes, intending to go away or preparing for bed. He asked him where his knife was, to which Byard replied that he had lost it about a mile beyond Warminster. He was taken to the police station where Sergeant Watts examined the clothes he had worn at the time, but he could find no trace of blood apart from two or three spots near the collar. Millward noted that there was a hole in the jacket pocket large enough for a pocket knife to have slipped through.

After the prosecution had put its case, Byard Greenland gave his version of the events:

We were very good friends together till where this accident was. My nephew said to me, 'Let's put things to rights now,' I said, 'What things Uriah?' And he said, 'Your passage up', I said, 'You know what you and I agreed to just now, we said we had cut half an acre of wheat between us more than Millgrove had',

Buckland Dinham, home to the Greenland families.

The Globe Inn, 2013 – scene of the inquest into Uriah Greenland's murder.

and he said, 'You owe me 5*d*' and I said, 'When you pay me 18*d* for damage done to the gun and I'll pay you 5*d*.'

He throwed down his things and ran towards me and said, 'Pay the man his passage!' He was quite drunk Sir, I couldn't see whether he fell back or walked back. He said, 'Bill I am hurted!' It was so dark I could not see whether he fell down or laid down. Millgrove went and heaved him up against the bank and told me to come and hold him while he went and got a light.

Meanwhile the coroner's inquest began at the Globe Inn, which, due to some administrative matters, took place without the presence of Greenland. Surgeon Mr Benjamin Mallam reported that the wound had gone through the collar of the waistcoat and through the shirt, which was folded several times. The handle of a knife had been discovered around 8 yards from the crime scene and was examined by Mallam in some detail. 'The knife handle produced was examined by me through a powerful magnifying glass. From the shoulder of the knife I took some rust and put a little water with it. I found some blood discs and on comparing them with some human blood I found they corresponded. I cannot swear positively at the blood discs found on the knife where human blood.' The blade was never found. The wound was caused by a sharp instrument and was too narrow to have been caused by a scythe. Proceeding to the state of the body, Mallam said he had found an incised wound five-eighths of an inch long on the left side of the chest. On removing the breastbone and some of the ribs, he found the chest filled with bloody fluid. The inner portion of the upper lobe of the left lung was pierced through, as was a portion of the heart. The direction of the wound was downwards and backwards, and the inference he drew from this was that the instrument descended downwards. The depth of the wound was rather more than 3 inches; the thickness of the shirt and waistcoat would have made an addition of half an inch too. Such a wound would have caused death within around three minutes. It could not have been produced by running against or falling upon a scythe, and there was no other wound. After hearing the evidence, the coroner's jury were asked to give their verdict and expressed great disquiet that the prisoner was not there to hear the evidence, but reluctantly gave their conclusion that Uriah Greenland had been murdered by his uncle, Byard Greenland.

Back at the police court, Mallam was asked to give his opinion on the state of the prisoner, who he believed to be sane and responsible for his actions. The court was told of a depression on the prisoner's head, which was believed to have been due to a young man hitting him with a pick ten or twelve years previously. The prisoner had been in the Somerset Militia but was discharged. His neighbour, James Bailey, explained that Byard was often subject to fits, which normally lasted around half an hour with him frothing at the mouth and Bailey doing his best to hold him. The fits occurred mainly on a Sunday morning after he had been drinking on the Saturday night. Millgrove stated that during the week they were

A traditional scythe in use.

away he had heard Byard say he would not drink any beer lest it should bring on a fit. After hearing all the evidence, the magistrates decided there was a case to answer and that the matter should be remanded to the assizes. The prisoner was then transported with strong irons on his legs and arms to Shepton Mallet jail to await his trial at the higher court.

On 19 December 1861, the matter reached Mr Justice Williams at the Taunton Assize Court and, as Greenland still had no proper legal representation, the court appointed the barrister Mr Brodrick for him. The witnesses gave much the same evidence as at the police court, with Byard sticking to his improbable story.

Brodrick did what he could in his defence, expressing his belief that the verdict must be either manslaughter or accident as there is no evidence of malice, no premeditation, and no argument between the two men that would warrant a finding of murder. Did Millgrove, who witnessed the act, consider the prisoner to be guilty of murder? If so, would he have left him alone with the deceased? The jury retired for around ten minutes and 'amidst the most breathless silence' the foreman of the jury said, 'We find the prisoner guilty of murder but we recommend him to the mercy of the court, believing that he did not premeditate the murder.'

Greenland was sentenced to death. When asked if he had anything to say, he replied, 'I am innocent as the child unborn; I did not wish to hurt my poor dear nephew.'

Luckily for Byard the jury's plea had not fallen upon deaf ears. Despite the judge summing up in favour of a guilty verdict, the case was indeed a very unusual one, as the defence had pointed out. Despite the occasional bad feeling that had occurred between the two it is difficult to make sense of the situation, as explained by either side. If Byard was intent upon killing Uriah, why do it in front of a witness? They had spent the last week together and lived next door to each other. Byard himself seemed unable to account for his own actions. The story about the scythe causing the injuries was very thin and easily disproved. He had taken the trouble to make a hole in his coat pocket through which his knife could have been lost, but then not bothered to hide the handle very well. He invented an argument with Uriah over the expenses, which the only witness claimed was untrue. In fact, it went against his own case as it gave a motive, which once the physical evidence was examined and his version proved to be false, made a sudden lashing out in anger quite credible and a finding of wilful murder justified. In summary, it seems that Byard had suffered some brain injury many years before, possibly causing him to commit impulsive acts and that the only point at issue between the two men was Byard's attack on Uriah's wife the previous spring. Uriah seemed able to let it go, but perhaps Byard's mental state left him seething with jealousy, rage and embarrassment over the matter.

The recommendation of the jury gained general approval and a petition was drawn up appealing for mercy due to the lack of any premeditation or immediate motive, whether of gain or otherwise, and put the death down to an instantaneous impulse due to a very peculiar temperament probably exacerbated by weakened

Right: A convict prison hulk.

Below: *The Western Gazette* of 20 October 1882 – interesting, if not strictly accurate.

provisional order for powers to authorise them to supply electricity.

BECKINGTON.

THE LATE DOUBLE MURDER.—The adjourned inquiry into the double murder and attempted murder at Beckington was held on Monday, at Frome, before Major Wickham. The court was densely crowded. The prisoner, Samuel Silas Phippen, wore a very dejected look, and was not represented. Mr. Percy W. Cruttwell put in the following certificate from Dr. Evans :—" I certify that George Greenland will not be in a fit state to attend court on Monday next, October 16.—W. G. EVANS, Lic. Royal College of Surgeons, Ireland. Beckington, October 14, 1882."—Mr. Supt. Deggan said that on Sunday the lad Greenland was able to sit up, and that by Tuesday week he would be able to be examined.—The prisoner was remanded till next Tuesday. —The murder is exciting as much attention as ever, and some amount of interest has been created from the fact that it has just been discovered that the family of the lad Greenland has been especially unfortunate. His uncle was the victim of the Buckland murder, in which he was murdered by a brother harvester, who first of all attempted to take liberties with his wife, and who afterwards picked a drunken quarrel with him, and then stabbed him with a scythe. The murderer was sentenced to be hung, but was subsequently transported. In Australia, while on ticket-of-leave, he shot two men and was afterwards shot himself, thus dying a miserable death in the bush. In addition to having an uncle murdered, an aunt and the grandfather of the lad met with their deaths from accidents, while his father in a similar manner lost one of his eyes a few years ago.

BRUTON

mental facilities due to a blow that had caused the depression in the skull. The petitioners were of the opinion that although the event may fall within the definition of murder, it should be considered as the lowest degree of that offence and was attended by several mitigating circumstances. The petition was signed by many respectable people, including the high sheriff of the county, and gained the support of an editorial in the *Taunton Courier*. The petition was successful and the sentence was commuted to one of life imprisonment.

Having escaped execution, Byard was moved from Taunton to Portsmouth in July 1862 and from there he was put aboard the *Clyde*, bound for western Australia. They sailed on 11 March 1863, arriving with 320 other convicts on 29 May 1863. He was released on parole in 1867 after a remarkably short time and moved to Perth where he continued his work as an agricultural labourer, marrying fellow ex-convict Catherine Latchford in 1870. It was reported that he broke his bail conditions in 1879 and stole two rolls of fencing wire. Byard Greenland died at Grove Farm, Freemantle, West Australia, from natural causes on 19 December 1879 at the age of forty-nine.

Uriah's widow, Elizabeth, married Thomas Sims, a weaver, and moved to No. 6 Button Street in Frome in 1867, followed by Goulds Ground. After Sims' death she found employment as a charwoman. Byard's wife, Jane, married a local labourer named Edward Stride and the family moved to Portobello Road, Kensington, and started another family. She died in 1911.

Buckland Dinham.

8. A GANG OF SMASHERS?

Superintendent Deggan had received a tip-off, and on the morning of Friday 21 July 1865 he positioned himself for observation on the platform at Frome railway station. Rather than his usual quarry of thieves, rogues and general malcontents, that morning he was looking out for a nine-year-old girl – little Rosa Roper. He didn't have long to wait and saw her standing at the station, clutching a parcel along with her bag. Deggan followed the little girl from the station to No. 14 Trinity Street, Frome, where she lived with her immediate family and grandmother.

As soon as she entered the house, Deggan closed in behind her. Then, as she passed the parcel to her grandmother, he immediately charged her and Rosa's mother with being in possession of counterfeit coins. With the parcel in his possession, Deggan went off to arrest Rosa's father, George Frederick Roper, a thirty-nine-year-old worker at Seer's woollen factory at Woodlands.

Back at the station, the package was opened and found to contain 36 counterfeit shillings, seven 2 shilling pieces and nine counterfeit half-crowns, all neatly wrapped in paper. The package had been addressed to Elizabeth Roper. Also seized at the home was a letter addressed to Mr G. Roper with a Bristol postmark: 'Those things you asked me for I planted. It was only one and I put it by myself and the damp got in and I must get it covered again. If you think you can do a whole one I can get one. I have sent 14 shillings and sixpence worth. I have sent it to 'E Roper, Railway, to be left till called for'.

Frome station has hardly changed since Roper's day.

The three were taken to the police station, where George Roper denied knowing anything about the matter, but was not helped when his sister Elizabeth exclaimed, 'Oh! Fred didn't you direct me to send to the station for a parcel addressed to Elizabeth Roper?' George denied that he had done any such thing, but said he was merely expecting a letter. Despite his denials, he was remanded by magistrate Sinkins to Shepton jail to await trial on the 25th.

At his trial his legal counsel, Mr Edlin, contended there was no evidence to suggest that the base coin had ever come into his possession or that he had any knowledge of it. The jury asked if the superintendent could state whether Roper had ever had any counterfeit coins in his possession, to which the judge had to point out that this was not a question that could be legally put. After a lengthy consultation, Roper was acquitted. The judge declared him a very lucky man, for if the question to the jury could have been answered they would have heard more of him than they did. Evidence of a defendant's previous convictions were not allowed to be mentioned in front of the jury.

Trinity Street in 2019.

No. 14 Trinity Street in 2021.

Despite his lucky escape George Roper was no innocent, having been sentenced to one month hard labour in Shepton prison for stealing two eels in 1850, three months hard labour for an unspecified offence in 1855, and at the time of his arrest was a 'ticket of leave man', having been convicted of breaking into a warehouse and stealing 45 yards of cloth, for which he had received eighteen months.

Shepton Mallet Prison as Roper would have known it.

Within the year he was in trouble again, having broken into the Co-operative stores in Long Row, Frome. The evidence was simple but conclusive. Mr Howell, the manager of the store, noticed chinks of light between the crevices of the store window at 1 a.m. and went to investigate. He tried the handle of the door but found it locked on the inside and had to force his way in, upon which time the prisoner sprang up on him, hitting him in the mouth and running away. It was found that he had prepared for carrying away bacon, tea and sugar, and two rolls of flannel – a total value of nearly £4. Howell knew him well and he did not stay at large for long. He was captured at 9 a.m. the same morning in a barley field around a mile from the town. Roper pleaded guilty at his trial in August and received seven years' penal servitude.

FROME.—*Burglary.*—On Saturday last Frederick George Roper, a ticket-of-leave man, was charged at the Police Court with burglariously entering the Co-operative Stores, in Long-row. The evidence was simple, but conclusive. Mr. Howell, the manager of the stores, got up at 1 o'clock on Friday morning, his wife being ill, and he let down the window of his bedroom. A man stood opposite, who went away when the window was opened. Seeing a light between the crevices of the store window, Mr. Howell went across. He tried the handle of the door, but finding it locked on the inside he burst it open. The prisoner sprang upon him, hit him in the mouth and then ran away. It was found that he had prepared bacon, tea, sugar, and two rolls of flannel for carrying away. About 9 o'clock in the morning he was captured in a barley field about a mile from the town. He was committed for trial.—*The Review*

The Bath Chronicle of 19 July 1866.

* '*Smasher*' – one who passes counterfeit money.

9. MURDER ON THE FARM

EVERYONE DOES A FOOLISH THING ONCE IN HIS LIFE

On the afternoon of Friday 29 September 1882, fourteen-year-old George Greenland was working at White Row Farm, Rudge, walking with the horse and cart towards the farmhouse having just returned from lunch, when he heard a gun go off. Making his way into the yard, he was shocked to find one of his fellow workers, Christopher Hill, lying dead in front of him, his face covered with blood. The lad looked around for his master and saw him walking towards him from the woods, 'Christopher is in there dead'! he exclaimed. The farmer, Samuel Phippen, was now only around 3 yards away. 'I know he is; I've been and shot him, and now I'm going to shoot you.' Phippen raised the shotgun and fired. The pellets smashed into the farm boy's arm, and he fell to the ground. Totally unconcerned at what he had done, the farmer walked off towards the fields, leaving his victim to make his way to the road as best he could in search of help.

The noise of the gunfire and the boy's cries had alerted people nearby who were beginning to gather around to see what was happening, and some began a search for the gunman. One of the first to see him was Dr Evans of Beckington, who stared in amazement as he saw Phippen raise his shotgun and point it at another of his workers, Charles Sheppard, who was ploughing a field nearby. He fired and the charge entered the poor fellow's head at the left side, killing him instantly. Phippen carried on across the fields and was next seen at Road Common, after which he made his way to the New Inn at Southwick. He propped his gun up against the settle, walked calmly up to the bar and asked the landlord, Mr Lusty, for a pint of beer and a cigar. Phippen was recognised by one of the customers and, as word of the murders had now reached nearby villages, Lusty slipped out quietly and fetched the village constable, PC George King. Upon arriving at the pub, the policeman found Phippen sitting on the settle enjoying his pint, the shotgun beside him. King said, 'Good evening Mr Phippen.' 'Good evening,' replied the suspect. The *Wiltshire Times* described the scene:

> With promptitude and zeal deserving of the highest commendation King at once charged Phippen with the murder, seized the gun and handcuffed his prisoner. In reply to the charge he simply replied that no one had seen him do it. He seemed to regard his arrest entirely as a matter of course and was perfectly calm when driven off a few minutes afterwards to Frome accompanied by PC King and Mr Lusty. Upon examination it was found that both gun barrels were loaded with cartridges which were immediately extracted by Mr Lusty. By this time

news of the murders had spread like wild fire and the inhabitants of Southwick, Road, and Beckington turned out in force to witness the conveyance of the prisoner to Frome. Phippen appeared morose and sullen but at times he whistled tunes and entered into conversation with his companions. When questioned about his motive he remarked that, 'Everyone does a foolish thing once in his life.' Upon their arrival at Frome he was placed in a cell and asked his gaolers if they had anything to drink. He seemed completely unconcerned at what had occurred, quickly got into bed fully clothed and fell asleep.

Meanwhile, back at the farm, the two bodies had been carried into the farmhouse and laid in the kitchen. 'Their appearance as seen at the time was extremely ghastly. In both instances the bullets had entered the left side of the men's heads and both must have died instantaneously. Their faces and hair were covered with blood and gore and their clothing stained very much. The view of the two corpses as seen by the fitful light of an oil lamp was one which it would be impossible to describe,' enthused the local paper. Both the victims were married. Hill was a widower of around thirty-eight years of age who left four dependent

White Row Farm.

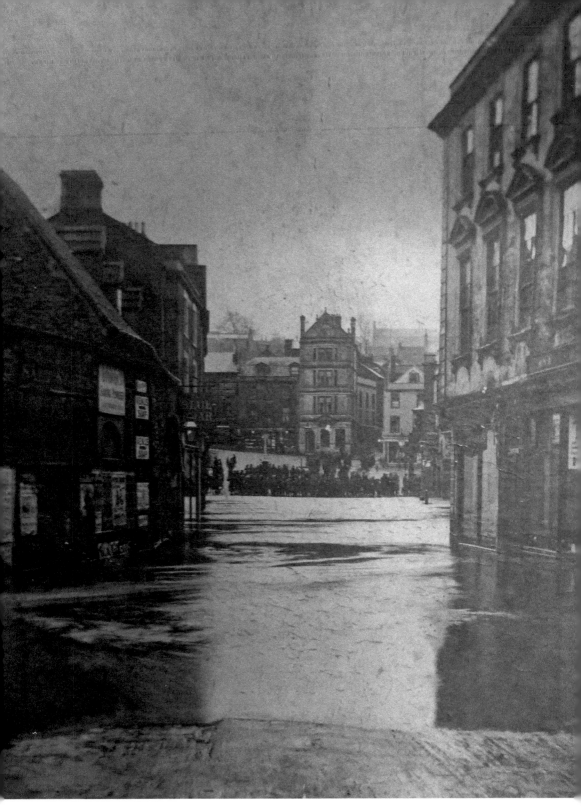

Frome Guardhouse (extreme left) and Market Place in the floods of 1901.

children. Sheppard, who was aged around sixty, left a widow and several grown up children. Both were quiet, inoffensive men. Two of Hill's sisters had acted as housekeepers at the farm as Phippen was unmarried. The farm boy, Greenland, was not too badly hurt as the bone was not fractured and it was hoped that amputation would be unnecessary.

The following Saturday, 30 September, the inquest was heard at White Row Farm in front of Dr Wybrants, the coroner. Phippen was brought in a cab from the guardhouse in Frome and his handcuffs were removed during the proceedings. He sat with his head buried in his hands and trembled considerably, though managed to speak coherently. Greenland was still too ill to attend. One of the witnesses, Charles Bourne, a nurseryman of Beckington, described running over to the farm upon hearing the news and spoke to Phippen from a distance of around 100 yards. Bourne asked him if there was anything wrong, to which he replied, 'Nothing in particular,' and made his way across the fields with his gun in his hands. The witness then went into the house and found Phippen's sister Ada there and asked her what she knew. They heard a shot from the woods and Ada said, 'You may depend upon it, he has shot himself.' Bourne and a few others then began to search for him, inquiring at the various cottages along the way, and found he had knocked at the door of Mrs Sainsbury, the baker, and bought a bottle of ginger beer. Eventually it was realised that Phippen had not shot himself as they had thought but shot another man instead. They learned a little later that he had been arrested. The prisoner's sister, Ada, gave evidence:

> I live at White Row Farm with my brother Samuel Phippen, he is a farmer and I act as housekeeper. My brother is 25 years of age and has been drinking hard for the past six months and it made him very strange. On the Friday morning he got up just before seven and had breakfast about ten. He had no liquor that morning in the house, he did drink in the house sometimes but could not get at the spirits as I kept the keys; the ale was all gone. He had his dinner at half past one and was asleep with his head on the table when I left for Rudge. I was away about an hour and saw him in the field when I returned, he had his gun in his hand and I heard a shot once towards the wood. I have twice seen my brother in a very outrageous state and we had a man in his bedroom to take care of him, Dr Evans attended him on the first occasion. He continued outrageous the first time rather over three days. I never heard there was any ill feeling shown by my brother towards the deceased men, they were in his employ about nine months.

Local surgeon William Godfrey Evans examined both bodies on the morning before the inquest and reported that they had been shot in the head with a small quantity of No. 5 or No. 6 shot – the sort used for birds or rabbits. It had driven small fragments of bone into the brain, flattening against the opposite side of the skull and causing instant death in both cases. The boy, Greenland, was suffering from a severe gunshot wound to his right arm with a few pellets lodged in his

thorax. He was judged too ill to attend the hearing and so the coroner and jury went around to his father's cottage where he explained that he had left school about a year ago and had been working on the farm for some months; he found Phippen to be a good master and had never quarrelled with him.

Deputy Chief Constable of Somerset Mr Bisgood reported he had been called to the prisoner the previous May and had found him suffering from *delirium tremens*, the result of withdrawing from a large alcohol intake, which can include hallucinations, confusion, hearing voices, shaking and seizures. On that occasion the state lasted for around four days, during which time he was rational when spoken to but not in his right mind. Phippen politely declined to ask questions of any of the witnesses and the jury retired to the Woolpack to continue their deliberations, having heard all the witnesses.

The coroner pointed out there could be no doubt that Phippen had carried out the murders; the only question was about his state of mind at the time. If a man committed a crime under the influence of drink, the law held him responsible; if he was a madman, it would be a different case altogether, but where a man lost his senses by drinking it was no excuse. The jury deliberated for a short time and then returned a verdict of wilful murder against Samuel Silas Phippen.

Ancient cottages in Goose Street.

The next stage in proceedings was an appearance before the Frome Magistrates, which took place the following Monday, 2 October, amid a packed courtroom. He was described as stoutly built, of dark complexion, rather under medium height, of repulsive countenance, and looking older than his twenty-five years. He sat with his elbows on his knees and his head down, swaying to and fro and shaking. The initial hearing was very brief, and the prisoner was remanded until Tuesday 10 October. He was conveyed in a cab to Shepton Mallet jail, around 18 miles from Frome, as prisoners could not be detained for more than three days at a police station. He was described as feeling his position more acutely than at first and as being occasionally very restless. After the hearing he was allowed visits from his mother, sister and uncle, the former of whom was deeply affected. Mr E. G. Ames, a solicitor from Frome, was retained for the prisoner's defence.

The funeral of Christopher Hill took place at Beckington on the Sunday afternoon, with the whole village turning out to follow the coffin from his home in Goose Street. Sheppard's took place on the following Tuesday at Berkeley.

The Woolpack, Beckington, an ancient coaching inn.

Details continued to emerge about the perpetrator of such an atrocious deed. Phippen was to be twenty-five years of age the following March and was the son of James and Lucy Phippen, late of Chickwell Farm, Laverton – they had retired around two years ago. He had four sisters, one of whom lived with him as housekeeper on the farm that he rented from George Pargetter, landlord of the Woolpack Inn. The farm covered 63 acres and it was assumed that Phippen Sr would supervise the running of it, but Samuel would not hear of it. He had been there since the previous Christmas, was unmarried and did not mix much with the locals, though he had been up the night before playing cards with several companions of his own age. It seems he was subject to epic drinking bouts, giving rise to episodes of *delirium tremens*, and his mental condition caused such anxiety that his friends felt compelled to tie him down on his bed on more than one occasion. It was stated there was insanity in the family. One local paper drew parallels with other recent events:

> The small district in which this occurred has already a most unenviable notoriety. This is the third murder of exceptional brutality that has occurred within a radius of considerably less than two miles. The Road murder, which was only cleared up by the confession of Constance Kent, occurred just over a mile away, while the Woolverton murder in which Britten a respectable farmer, first murdered his victim and then attempted to cover up his crime by setting fire to his homestead, occurred about the same distance from Beckington. The three places may be described as forming the points of a triangle. But for absolute horror – the whole of the mischief done being entirely without object – the present murder puts both the others in the shade.

A full hearing in front of the magistrates was postponed on several occasions, waiting for Greenland to be well enough to attend court. During this time interesting facts arose about his family, which seems to have been a most unlucky one. His uncle was the victim of the Buckland murder of 1861 in which he was stabbed by his own uncle, Byard Greenland (see Chapter 7). The killer had been sentenced to be hanged but was transported to Australia. In addition, an aunt and his grandfather met their deaths from accidents, and his father lost one of his eyes a few years ago.

On Friday 3 November, Phippen's trial began at the Bristol & Somerset Assize before Lord Justice Bowen. The prisoner was described as 'dejected and paying little attention to the evidence' and was seen to be weeping at times. Mr Bompas QC opened the case for the prosecution by stating that the basic facts were not in dispute and that 'the only question admitting of a doubt in this case was whether the prisoner could satisfy the jury that he was labouring under mental disease, not originating in his own acts but coming upon him by the will of Providence and rendering him unaccountable for his conduct'.

The Crown Inn.

Harriet Wingrove, landlady of the Crown Inn at Beckington, stated that Phippen was in her pub on the morning of the murders. He had two pints of beer and read the paper. He then left for a while but returned later for another pint. He appeared quite sober. His sister and housekeeper Ada said that up to the age of eighteen her brother had been a total abstainer and had always been very quiet, but the previous May he had 'given way to habits of drinking' and had a severe attack of *delirium tremens* in which he became very violent and they had to call in men to attend to him. Christopher Hill had been one of these men, and they had always been good friends. He had a second attack in August and Ada had locked away all the spirits in the house. On the Sunday before the murders he had appeared very strange and looked very wild, complaining of pains in his head and sleeping a great deal. On the night before the shootings he had tried to play cards, but couldn't as he became very confused. In the morning he was walking up and down the yard in a very peculiar way, and had been strange for a month or more.

Dr Evans helpfully pointed out that a number of the prisoner's relatives had been confined to lunatic asylums and that this would strengthen the supposition that there was a tendency to insanity with the prisoner and that drinking would increase that tendency. He also explained that 'the victims of a monomaniac were either those who were indifferent to him or those that were very dear to him, whereas the victims of a criminal were those who opposed his wishes and desires. The sane criminal endeavoured to conceal, or if taken, deny the crime, with the monomaniac the reverse was true'.

Joseph Lough, a warden at Shepton Gaol, said that on the night of 2 October Phippen had sprung out of bed and begged the witness to stay with him as he had only half an hour to live, saying that there were two men waiting for him at the window and if he left him he would only find his bones when he returned.

The defence case opened with Mr Collins QC stating that Samuel Phippen had not had a drink until the age of eighteen and was a quiet, industrious boy but with a rather weak intellect. His father was a confirmed drunkard and several of his mother's family were insane – insanity ran through the whole of them. The mother's father had died a few days after leaving Dorchester Asylum and her sister, who was also insane, had died in the Wells Asylum. One of her brothers suffered from epileptic fits and a cousin on her mother's side was also confined in a private asylum. Her father's brother, though not confined, was notoriously crazy and not right in his mind. A first cousin of her husband had died by suicide. Phippen's mother, Lucy, was called and confirmed all of the above.

As a further example, in August 1857 Samuel's father, James, took a course that might not be thought of as the action of a sober or rational man. Martha Allen, a girl of around sixteen, was walking along a public footpath through one of his fields with four small children and their nanny. James Phippen, who had been 'standing behind a tree that was bigger than himself so as not to be seen', stated that he 'saw the prisoner take some wheat out of my sheaves and I took 44 ears out of her hand'. He then marched her at gun point to her mistress's house, who offered to put up any amount of bail for her release. The girl's explanation was that she had been playing with the children and making a nosegay out of the corn for them. Phippen claimed that he'd had a good deal of corn stolen recently and wanted to make an example of the girl.

To his embarrassment, Martha had been advised to prove her case before a judge and jury rather than risk a conviction in front of a magistrate. That the case was blown out of all proportion was a credit to Martha Allen, who could have meekly accepted a small fine from the magistrates, and to her legal advisor, Mr Hawkes. Between them they made the bullying Samuel Phippen a laughing stock. The corn was valued at 1*d*, and the jury acquitted her immediately.

Returning to the present case, Dr W. J. Manning, medical superintendent of the Laverstock Asylum in Salisbury, saw the prisoner at Shepton and questioned him about the murders, but he could give no detailed account of them. He added that the pains in his head and general drowsiness indicated a diseased brain that had

formed into homicidal mania and that he was utterly incapable of knowing right from wrong. Such an attack could last for a few minutes or a few hours, and after it had passed the man would become rational. His Honour Lord Justice Bowen then spent an hour summing up and sent the jury out to consider the evidence. They returned within five minutes with a verdict of not guilty on the grounds that Phippen had been insane at the time he committed the acts. The judge ordered him to be detained at Her Majesty's pleasure.

The Gloucester Journal, 11 November 1882.

THE STRANGE DOUBLE MURDER NEAR FROME.

At the Bristol Assizes yesterday week, Samuel Silas Phippen, farmer, single, and aged 24, was indicted before Lord Justice Bowen for the murder of Christopher Hill and Charles Sheppard at Beckington, near Frome, on September 29th, and for shooting at George Greenland, with intent to murder. Mr. Bompas, Q.C., with Mr. Chas. Matthews, prosecuted ; and the prisoner was defended by Mr. Collins, Q.C., and Mr. Poole. The facts were undisputed ; the defence set up was insanity. On the day named the prisoner, who lived with his sister at White-row Farm, Beckington, was seen by a boy named Greenland to take up his double-barrelled breechloader and fire it deliberately and without a word at a labourer named Christopher Hill, aged between thirty and forty, as he was standing within the washhouse of the prisoner's farm. Hill received the bullet in his head and dropped down dead. Greenland said to the prisoner, "Oh, master, you have shot him ; " the prisoner replied, " Yes, and I mean to shoot you." He fired the other barrel at the boy, who, putting up his arm to protect himself, received severe injuries in that and in his throat, from which, however, he recovered. The prisoner, evidently believing he had killed Greenland, walked to Standerwick Court, where, seeing an old man of sixty, named Charles Sheppard, ploughing, he shot him through the head, killing him also instantly. He was afterwards apprehended at a public-house with his loaded rifle still in his possession. Several physicians testified that the prisoner's brain was diseased, and that he knew nothing the next day of his act, which was clearly that of a madman. Other witnesses proved that insanity had been hereditary in the family for generations ; and the prisoner was ordered to be detained during her Majesty's pleasure.

At this point most investigations would come to an end, but we are lucky in being able to take the matter further. Phippen was sent to Broadmoor Hospital, the first custom-built criminal asylum in the world, which opened its doors in 1863.

He was released in 1893 and found his way to Park Farm at Hadleigh in Essex. This was an idealistic project started by the Salvation Army a couple of years before and was part of that organisation's 'Darkest England Scheme' to raise the 'submerged tenth' of society from the slums and moral decay of the cities and get them back to the land. This was envisaged as a three-step process: the Hadleigh Colony would take in destitute but able-bodied men, some of whom had been temporarily 'rehabilitated' in the Salvation Army's City Colony in London. At Hadleigh, these men would undergo agricultural training and moral rehabilitation in order to become 'capable, industrious citizens'. Some men would remain in England, but most would immigrate to British colonies overseas – notably Canada, Australia and New Zealand. The first colonists to emigrate from Hadleigh left in 1901. By 1910, it was evident that sending migrants to land settlements overseas was no longer viable and the colony moved away from the rehabilitation of older men towards the training of younger men, who could obtain paid jobs such as farmhands.

The census for 1901 shows Samuel Phippen as a resident at Hadleigh, aged forty-three and employed as a labourer in a market garden. There were eleven other boarders on census night from all over the country and Samuel's luck seems

Broadmoor Asylum for the Criminally Insane, 1861.

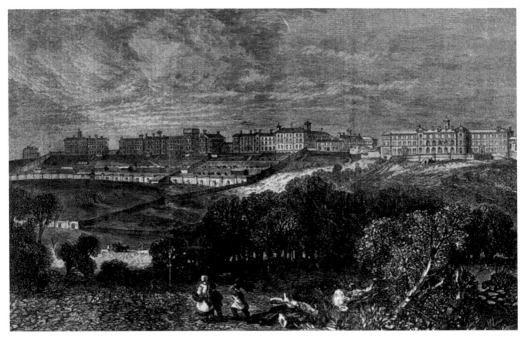

Hadleigh, *c.* 1895. (Hadleigh & Thundersley Community Archive)

to have improved. That same year he married a young lady, Edith Susannah Ash, a twenty-eight-year-old Londoner and children's maid living in at St Vincent's Road, Southend on Sea, around 8 miles away. They were still married nine years later in the census of 1911. He was then a 'jobbing gardener' and they were living in a ten-roomed house at Holdenhurst Road in Bournemouth. The pair appear on the electoral roll up until 1921 when they have moved to Kingswell Road, Ensbury Park, in the Bournemouth suburbs. Records show that he died in Wimborne, Dorset, in 1934 at the age of around seventy-seven.

As for the injured victim, George Greenland, he survived and improved his lot in life by becoming chauffeur to local GP Dr Rattray. By one of the bizarre coincidences that beset these tales, he was driving the car on the day in 1917 when Captain Ryall lost his senses and started shooting people at random. Rattray was called out to help and was shot in the elbow – exactly the same place as Greenland all those years ago. Captain Ryall's case appears in our first book *Foul Deeds and Suspicious Deaths in Frome* (2018).

White Row
Farmhouse
in 2021.

White Row Farm.

10. THE TRIPLE TRAGEDY OF 1936

On the morning of Saturday 18 July 1936, one of the most intriguing mysteries in Frome's recent history began to unfold. At 9.40 a.m., Mr Wheeler, a local milkman doing his rounds, knocked on the door of No. 1 Gentle Street, the home of Alfred and Alice Williams and their six-year-old son David, but received no reply. Noticing that the curtains were still drawn, he talked to the neighbours who were surprised that there was no one about at that hour. Mrs Greatwood, who ran the Waggon & Horses two doors up the road, said she was worried the house was still shut up as the family were normally up early and the club where Alfred worked was usually open by now.

Wheeler hammered on the door and threw stones at the bedroom window, but after failing to get any response he went to fetch Police Sergeant Townsend, who was on traffic duty at the top of Bath Street. Accompanied by the sergeant, the pair entered the house via a cellar that connected the club to the house and

Gentle Street – the scene of the crime.

Waggon & Horses in 1949, home to Mrs Greatwood. (Courtesy of Frome Museum)

made their way upstairs. Upon entering the back bedroom they saw Alfred John Williams lying peacefully asleep in bed – or so they thought. When they drew the curtains and inspected further they realised Williams was dead. They made their way to the front bedroom but had trouble opening the door as a trunk had been placed behind it. Once inside, they found the bodies of Alice and her son David suspended from a cord attached to a coat peg on the back of the door – both were dressed in their night clothes and both had been dead for some hours. None of the neighbours had heard a sound. During the day Superintendent Norris took charge of the investigation and tried to establish the series of events.

Williams, known as Jack, was a fit and healthy man of thirty-eight, the son of a brewer's drayman from Beckington. He had served with the Hampshires in India and Mesopotamia during the First World War, was a keen footballer and had worked for a builder before taking up the position of steward at the Frome United Services Club where he had been for the past seven years. The family lived next door to the club and Jack took his duties very seriously – he was in the club almost every day. He had been married to his wife, Alice, aged thirty-seven, for nine years and according to those who knew them they were devoted to each other. They had one son, David, who was six years old and suffered from

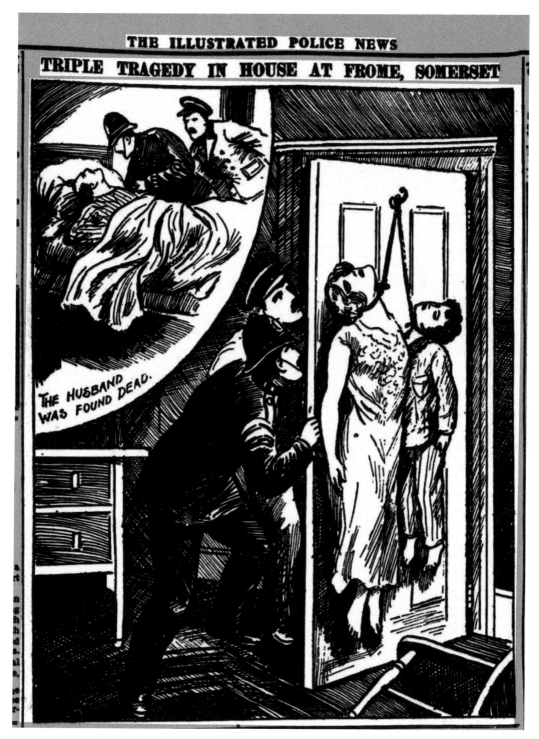

The Illustrated Police News.

a foreshortened forearm, which the couple were distressed to learn the previous May, was not going to improve as he grew up. People close to them said that despite being very distressed by the news they had come to accept the situation as time went on. They were planning a family holiday to Exmouth during the forthcoming August bank holiday.

On the evening of the 17th, Jack had been playing cards and cribbage while discussing cricket with Herbert Vennell, who lived directly across the road at No. 10 Gentle Street and had known him for around four years. He later gave evidence that Jack would drink one or two glasses of beer in the evening but was never seen to drink spirits. At around 10.10 p.m., Alice Williams arrived with their son David, having just returned from a fête. Mr Vennell left and crossed the road to his home shortly before 11 p.m., wishing the family good night, and Jack said that he would see him the following day. At around 12.45 a.m., Vennell was awakened by a rattling window and noticed the light in the William's front bedroom being turned off as he tried to fix it. Mrs Vennell had known Alice for around fifteen years; they were close friends and good neighbours who were devoted to each other.

A post-mortem examination of Jack's body took place on 20 July and an inquest was held on the following day, during which the pathologist gave his opinion that death was due to natural causes as there were no signs of injury to the body and he had been dead for around ten hours. It was not possible to give the cause of death during the present proceedings and the case was adjourned for a month to await the results of a toxicology report from the county analyst.

Dr Charles Johnson visited later that morning. According to a report in the *Western Daily Press* for 22 July: 'In the bedroom I saw Alice Mabel Williams lying on the floor, she had evidently died of strangulation and there were deep marks of a cord around her neck. Lying on the bed I saw the child who had also died of strangulation. Apart from the cord there were no marks of violence on any of the bodies.'

On 23 July, the three were buried together at Christchurch in a private ceremony, but despite the family trying to keep the matter secret a large crowd had gathered outside.

The inquest reconvened on 20 August at Frome police station. Detective Sergeant Whittle gave evidence to the jury that everything in the house was in order. Tea had been in the teapot ready for making in the morning, but on the living room table was a newspaper that contained two references to hanging. An empty glass tumbler smelt strongly of whisky. Downstairs there were two plates and two cups that had contained coca. The bed had been occupied by two people, but that the other person had made no impression upon the pillow. He was certain that no other party was involved in the events.

The coroner Mr C. L. Rutter said it may be that Jack's death had been caused by his wife or that she had woken up and found him dead. Pathologist Dr Godfrey Parker said that his death was due to asphyxia; his heart was healthy

Christchurch, Frome.

and there were no signs of any drugs or poison in his stomach. The inquest lasted over four hours and the jury took around half an hour to reach their verdict, which was that the man died from asphyxiation, but there was no evidence of the direct cause; that the boy died from asphyxiation by hanging and was murdered by his mother; and that the mother committed suicide by hanging while of unsound mind.

Evidence was given that the previous February Jack had been treated for a peritonsillar abscess or quinsy (a throat abscess) along with slight pains in his shoulder and back. The most likely cause of death was that he was sleeping in such a position that this condition had caused sleep apnoea – he had simply stopped breathing and asphyxiated in his sleep.

TRIPLE TRAGEDY INQUEST

VERDICT OF MURDER AND SUICIDE AGAINST MOTHER

A verdict that the man died of asphyxia from unknown causes, and that his wife murdered her son and then committed suicide, was returned at the resumed inquest held at Frome (Somerset) on Albert John Williams, aged 38; his wife, Alice Mabel Williams, aged 37, and their only son, David, aged 6, who were found dead in a house at Gentle Street, Frome, on the morning of Saturday, July 18.

Williams was found dead in bed, and his wife and child hanging by a cord from hooks on the door of an adjoining room.

Evidence was given by Dr. Godfrey Carter, Pathologist to Taunton Hospital, and Mr. F. Tilling, the county analyst. Dr. Carter asserted that death in each case was due to asphyxia by hanging in the cases of the mother and child. He was not prepared to state the direct cause of Williams' death from asphyxia.

Mr. Tilling stated there was no trace of poison in either of the bodies.

When the inquest was opened, Dr. C. H. Farley Johnston said that in the case of the man rigor mortis was marked, and from it he inferred that Williams had been dead for possibly 10 hours.

Williams was steward of the United Services Club.

Illustrated London News, 27 August 1936.

Frome Police Station and Law Courts – the scene of the inquest.

The coroner was of the opinion that Alice Williams must have been a very determined woman in order to asphyxiate herself by hanging with her feet on the ground, but also considered that this need not have been the case. In order for the suicide to be 'successful', the end of the cord not used to make the noose must be attached to something solid that will not break or move. In this case, a clothes peg fixed to the back of the door. In films, people are seen arranging the rope with them standing on a chair, then kicking the chair away, but this is not necessary. Whatever position is assumed, whether that be lying, kneeling or feet lightly on the ground, the noose tightens sufficiently to constrict the carotid arteries and jugular vein, which can be achieved by simply bending the knees, putting them on the floor, sitting or lying down. In one study of hangings, 63 per cent of the victims were in contact with the ground, which would cause the blood flow to and from the head to be constricted quickly, achieving a loss of consciousness.

The likely chain of events is that after putting David to bed the pair had a cup of cocoa and Jack went up to bed and suffered breathing difficulties, which caused him to die in his sleep. Alice followed shortly after only to find, as she got into bed, that her husband was dead. Unable to cope with the situation, she suffered a breakdown and saw no alternative but the kill her son and herself.

Gentle Street, Frome.

Also available from Amberley Publishing

·SECRET·
FROME

ANDREW PICKERING &
GARY KEARLEY

Explore the secret history of Frome and the surrounding area through
an intriguing selection of stories, facts and photographs.

978 1 4456 7266 3

amberley-books.com / (+44) 1453 847800